DAVID NASH

FORMS INTO TIME

With an essay by MARINA WARNER

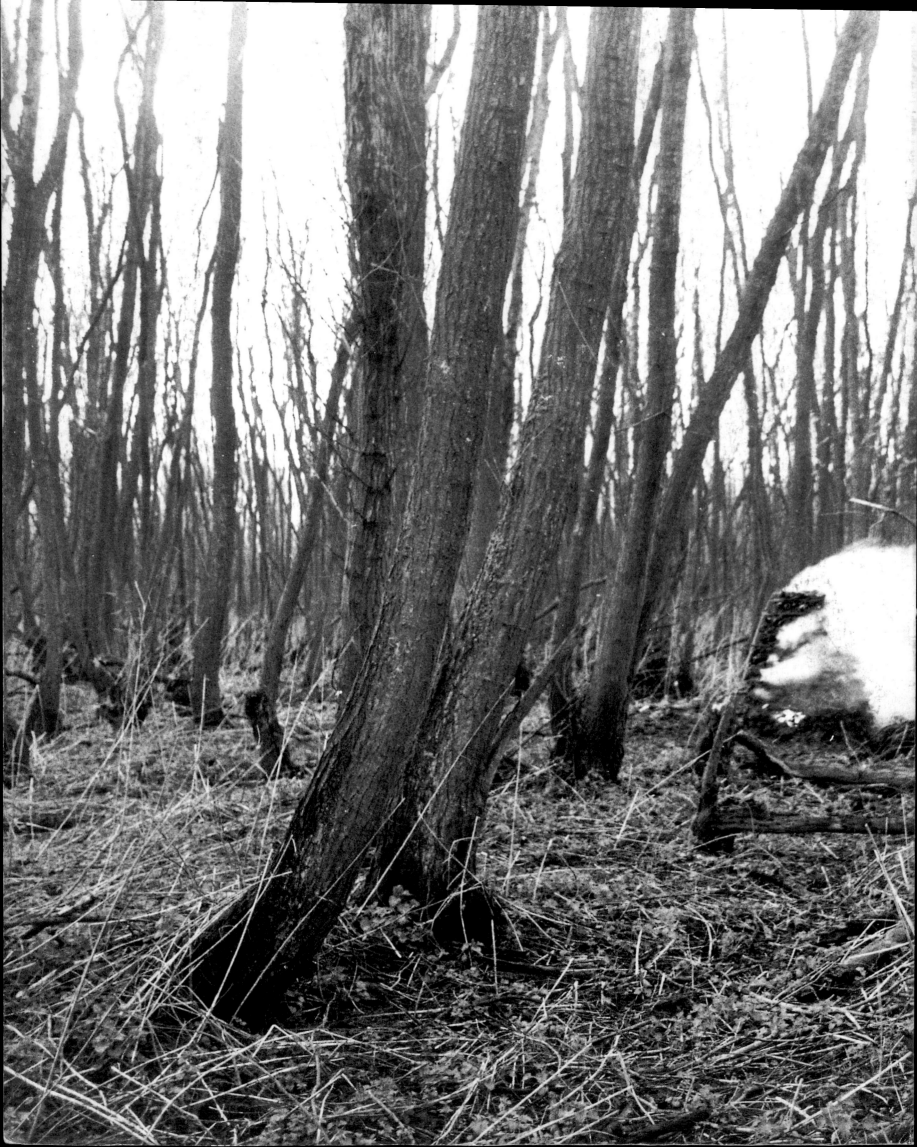

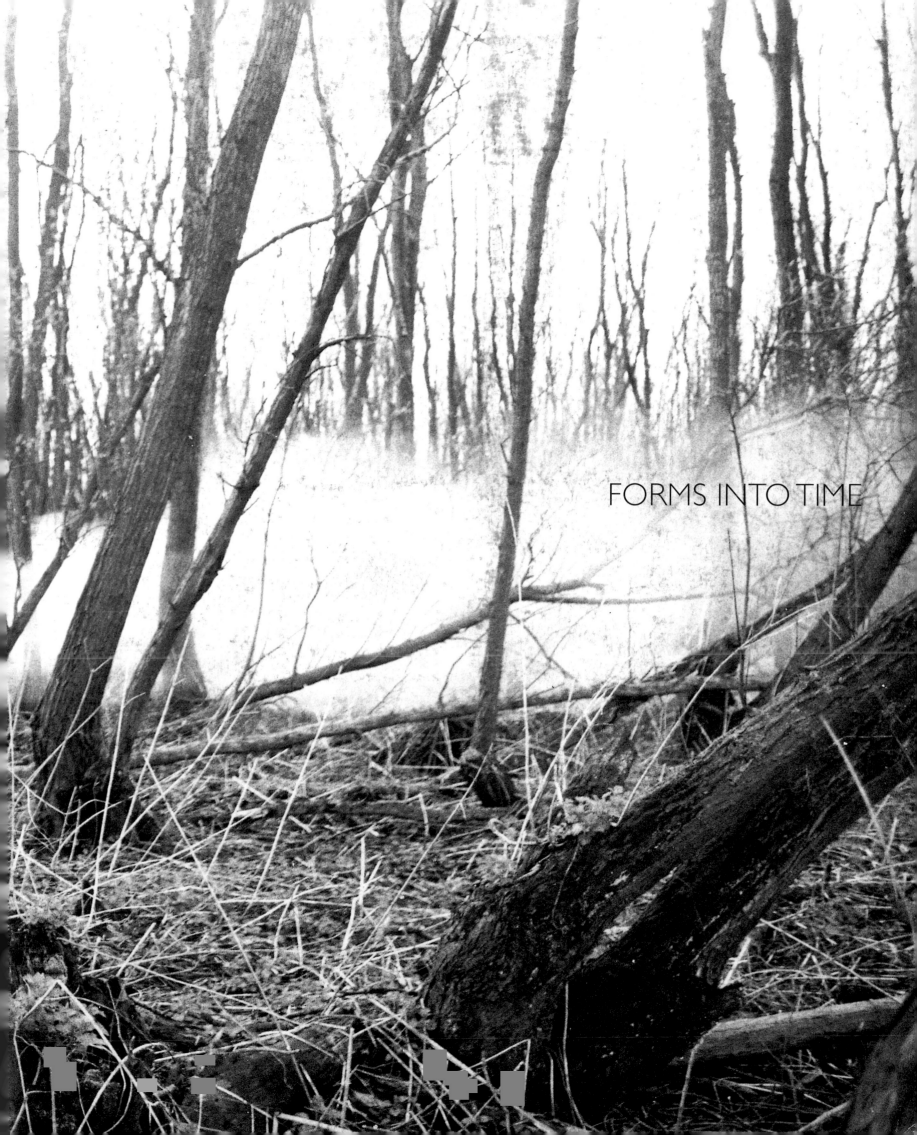

FORMS INTO TIME

ACKNOWLEDGEMENTS

To my elder brother Chris, who took playing seriously and let me join in.

With special thanks to Maria Hayes; Carolyn Iolo; Paul Kay; Annely Juda Fine Art, London; the LA Louver Gallery, Los Angeles; Galerij S65, Aalst (Belgium); and the Nishimura Gallery, Tokyo.

I would also like to thank those at Academy Editions who have worked with me to make this book possible: Nicola Kearton, Andrea Bettella, Mario Bettella, Sonya Winner and Rachel Bean.

Photography: David Nash, Sue Wells, Sue Omerod, Martin Orom, William Nettles and Sakae Fukuoka.

COVER: *Charred Sphere in Charred Redwood Stump*, 1989, Bear Gulch, California

PAGES 2-3: *Sticks and Clay Stove*, 1981, Beisbos, The Netherlands

PAGES 126-27: Cae'n-y-Coed, North Wales, 1981 (photo: Ikon Gallery, Birmingham)

ART & DESIGN Monograph

First published in Great Britain in 1996 by
ACADEMY EDITIONS

An imprint of
ACADEMY GROUP LTD
42 Leinster Gardens, London W2 3AN
Member of the VCH Publishing Group

ISBN: 1 85490 353 5

Distributed to the trade in the USA by
NATIONAL BOOK NETWORK, INC
4720 Boston Way, Lanham, Maryland 20706

Printed and bound in Singapore

CONTENTS

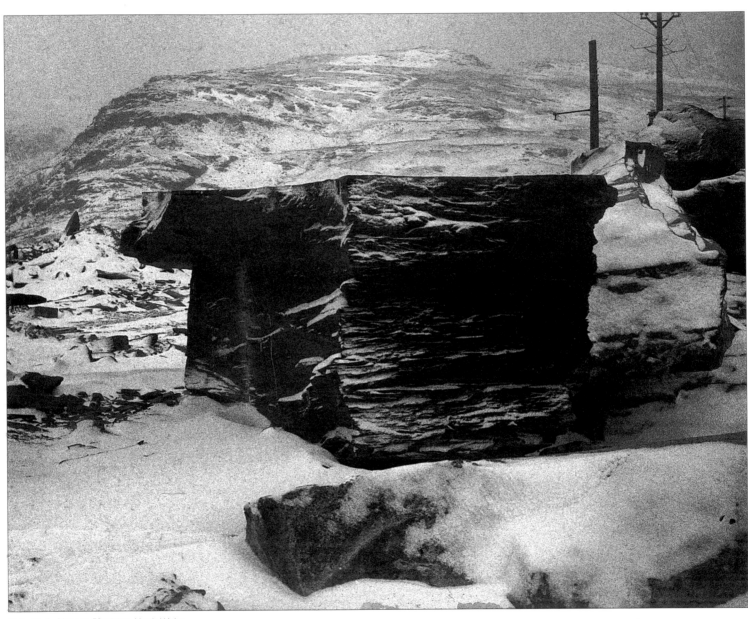

Slate block, Blaenau Ffestiniog, North Wales

FOREWORD

BY NICOLA KEARTON

Two complementary approaches to wood, combining both its material aspect as well as a complex investigation of its cultural and metaphysical aspects, appear here in the work of sculptor David Nash and writer Marina Warner. Both are concerned with the human presence and involvement in nature, with wood and its primal connotations of shelter and fuel, life and death. Nash's career has been a profound exploration into the possibilities of form inherent in trees and timber. Marina Warner's work has thrown new light into areas of myth and symbolism as witnessed by her highly original exploration into fairy tales *From the Beast to the Blonde: On Fairy Tales and their Tellers*.

The sculptural practice of David Nash is full of allusions to the human uses of wood. As Marina Warner writes, his bowls, spoons and vessels, steps and ladders, hearths and stoves 'point to the common artefacts of daily life and to the craft-work of ordinary survival'. His work also harks back to a time when the country was a working environment, not empty except for the passing hiker or weekender, but full of people carrying on their daily affairs. In his pieces one senses the presence of the forester, charcoal burner, carpenter, the farmer laying hedges, pruning trees. Gathered from a lifetime of research into traditional methods of woodsmanship from all around the world, his work evokes those agricultural skills increasingly lost in an industrial age. His texts reiterate his knowledge of wood as a material, of the practical methods of handling oak as opposed to ash, of the way nature and time intervene to 'crack and warp and bend'.

In their very physicality, his pieces bring to mind the potent symbolism of wood hidden within our shared cultural imagination. As Marina Warner details in her essay, wood in mythology is a symbol of both life and death, as instanced in the cross of the Resurrection where both meanings are implicit. Nash is well aware of these links in his work. In seeking to unite the spiritual with the material, nature with culture, he is trying to break out of that dualism of opposites which, as Marina Warner writes, obscures 'the crucial links between art and scientific explorings, between the faculty of sight and inner vision, between alchemy, numerology, religious and artistic inspiration'.

In exploring David Nash's work and the sources of his inspiration, Marina Warner expands facets of his work in the context of her own studies into the nature and mythology of wood. Myth also suggests those layers of human involvement with the landscape, traces of the human presence which are set apart from the great deeds of history but which link with the lives of ordinary people. The woodcutter and his daughter who appear so often in Germanic fairy stories bear witness to a time when the forest was enmeshed in people's lives. The loss of contact with nature and with the sense of place are all too obvious in the twentieth century, but in the work of both David Nash and Marina Warner there is a profound element of hope. David Nash planted his ash dome, a living sculpture which will take thirty years to mature, as 'an act of faith in the future'. Marina Warner writes at the end of her study on the symbolism of wood: 'The tree of life is above all the start of a story, a sign of refusing despair, in desperate times.'[1]

Note

1 Marina Warner, 'Signs of the Fifth Element', *The Tree of Life: New Images of an Ancient Symbol*, South Bank Centre/Common Ground (London), 1989.

THROUGH THE NARROW DOOR
FORMS INTO TIME

BY MARINA WARNER

Shadows under the Slate

The waste tip of a slate quarry fills the view from the windows of the house in Blaenau Ffestiniog, North Wales, where David Nash lives and works. The bleak escarpment rears up, its edges stark diagonals against the sky, its sides scarred by the diagonal grooves of the quarry gear, the trucks and pulleys that the slate miners use to move the stones. Because never more than a tiny fraction of the slates split finely enough along the stone's natural grain for the purposes of rooftiling, more and more slabs are discarded as imperfect or unusable and are emptied out of the trucks from the summit. Nothing grows on the pyramid of black, grey stone; but its own growth continues.

It's hard to imagine why an artist who works with living trees and with the natural warp and weave of wood should live in the shadow of this desolate heap of rubble. Yet the tip is compelling; these loose, dark, giant heaps of waste material outside his window have a persistent life of their own in David Nash's imagination: their severity challenges him, on a daily basis, and he responds by resisting them with the comparatively merciful and vital material of wood, refusing their stoniness, their shadows, their bulk. The scenery is a kind of sculpture in the wild, itself always changing, always growing, made up of smaller sculptures, the eroded forms of the tumbled slabs, which resemble fallen menhirs, and at close quarters dwarf the onlooker by their scale. When it's wet, they gleam blueblack with almost liquorice invitingness, like pebbles washed by the sea. When it's dry, they lose their shine and liveliness, and in their dry, inert weight seem to epitomise the mineral realm of down below.

David Nash says he learns from them daily, from their natural geometry, their simplicity and force, their changeability, their inner life. They set the standard for the laws of organic form which he obeys. Saint Bernard advised the reformed Cistercian order to keep their church design minimal: 'There must be no decoration,' he wrote, 'only proportion'.[1] David Nash, whose work reveals affinities with medieval mystics' thinking about nature, has searched since he was first an art student for the possibilities of form that trees and timber will yield, without decoration, with a sense of their own laws of proportion.

The artist first came to Blaenau Ffestiniog thirty years ago; he found a Welsh chapel, a harmonious space large enough for a sculptor's studio, and bought it for a pittance (£200, which he could just afford, aged 22 and fresh out of college). He felt profound sympathy with the conjunction of the elements in this small, once flourishing but now quiet industrial town set in the dramatic mountains of North Wales, ten miles inland from the Irish Channel. Blaenau was a retreat which could act as a resource for someone who identifies with the 'homeless soul' invoked by the German mystical thinker Rudolf Steiner. By 'homeless soul' Steiner meant those 'who may pass patiently through childhood', but who long 'for an attitude to life which [is] not laid out in advance; a longing for the spirit in the chaos of contemporary spiritual life'.[2]

The London of his art school years was too noisy, cynical and competitive for David Nash. Besides, there were practical reasons: he was already working with timber in the first assemblages he made as a student: Tatlin-like, soaring towers of motley objects, found as well as made. In Wales he could use the living wood and the organic debris of the forests. By making his move to a remote place set in deep country, Nash clarified the active task he was undertaking as an artist of nature: to enter and grasp the landscape, to work its form by taking part in its making. He was rejecting the spectator's and outsider's stance, refusing to stand back in wonder like a Romantic gazing at the moon from a hilltop and picturing it as it appears to the eye. He had originally started out as a painter, but he was drawn to 'the fact of sculpture', the action and physical relation required by the medium. He loves the way the land is carved and moulded over time, by sheep walking certain tracks and lying in the lea of walls or trees (where, he says, they gradually make 'an oval patch – a peaceful space, innocent and holy').

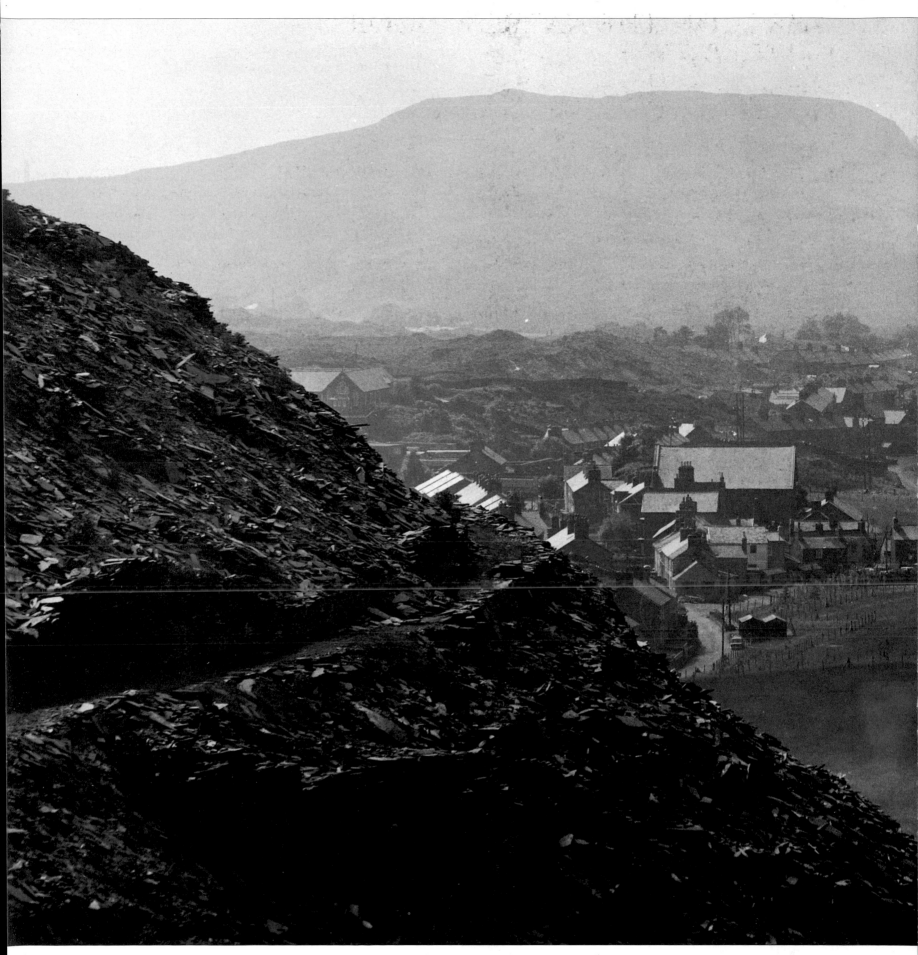

Rhiw Brifdyr, Blaenau Ffestiniog, North Wales

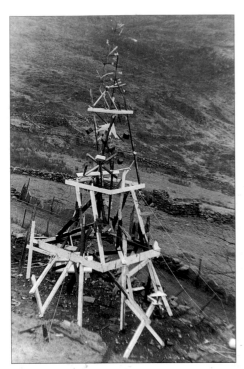

First Tower, 1967-68, Blaenau Ffestiniog, North Wales

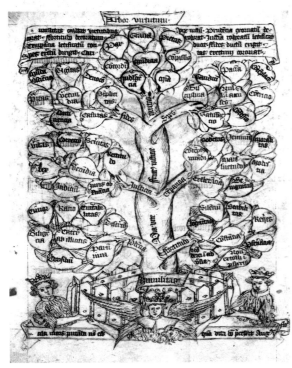

Tree of Virtues, *from a late 14th-century English compendium of tables*
(photo: The Warburg Institute, source: London BL MS Roy I B X)

Material Anatomies

David Nash sees himself as a researcher, and as he quarries the trees he's given to work with, he anatomises them; large drawings develop the relationship of his works over time, the metamorphoses of the original parent into boulder, vessel, throne, column. His early sketches on this theme carry the same sense of awe before the full potential of natural properties that one finds in medieval literature about God's wonders: they recall, for example, the hero Tristan's precise instructions on how to excoriate and quarter a hart after the hunt in Gottfried von Strassburg's thirteenth-century German romance.[3] They distinguish every part of the tree, from root to crown, in a mapping and naming of parts that adds up to a survey of Nash's life's work.

In recent variations on this retrospective review of his art, David Nash has set aside his previous image of a linear journey to concentrate on the tree as a sign in itself; he has consequently chosen to draw on a vertical axis. He wants to reproduce the branching structure of a tree, and to strike resonances with the widespread use of arboreal metaphor, in language and image. For the way a tree grows and unifies disparate elements, holding in a single identity ever evolving and mutating bark, leaves, twigs and other constituent parts, has structured numerous depictions of complex relationships between parts and whole. Medieval analyses of the soul and of consciousness, as well as schemata enumerating the virtues and vices, the arts and sciences, the principles and elements of wisdom, frequently adapted the stemma, or family tree, to elaborate the ideas.[4] At the height of the scientific revolution, in 1866, when the biologist Ernst Haeckel was drawing up the evolutionary relation of species, he still took up the metaphor, and produced an exquisite, sensitive, willow-like picture of the first phylogenetic tree of life. David Nash is attracted to these universalising diagrams: his knowledge of trees opens up metaphors for other knowledges, and makes the image of a tree capable of embracing the whole of nature in its branches and assigning humans their place within it.

In his sculpture, the anatomies of trees move from the large, distant overview, to the microscopic close-up. He sees into the timber, he follows its whorls and uncovers its nodes and veins, he leaves a trace of his presence in the scouring marks of the saw or the cuneiform of the chisel, but otherwise offers the wood unvarnished and unadorned.[5] He also likes to allow wood

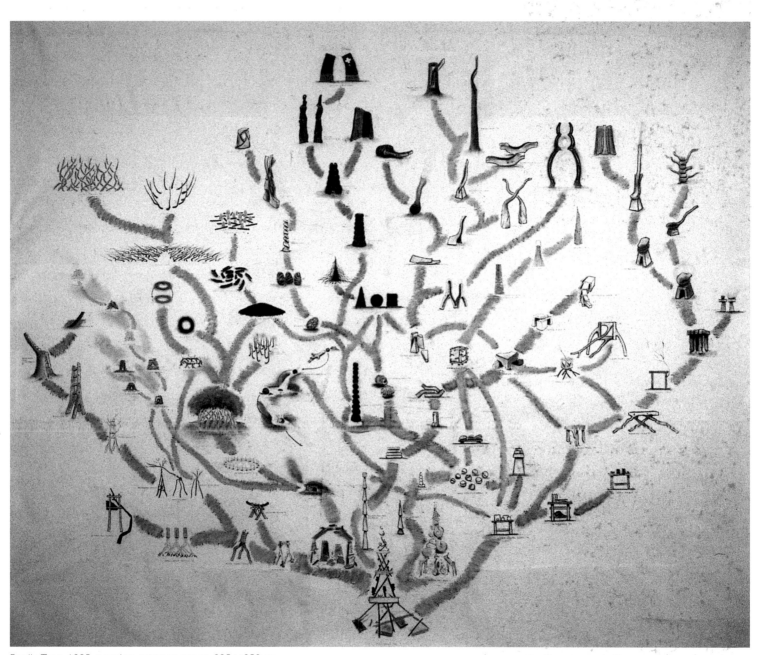

Family Tree, *1995, pastel on paper on canvas, 235 × 350 cm*

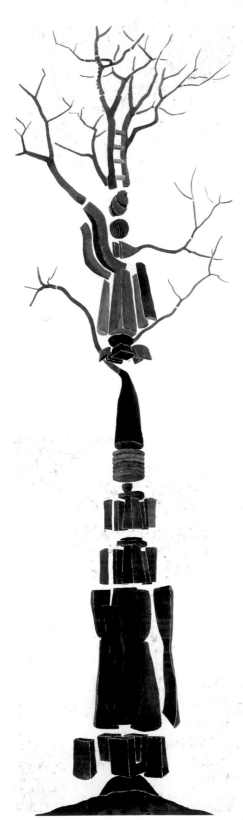

Chêne, 1988, watercolour on paper, 212 × 60 cm,
Tournus project, France

to have its own way; he describes his sculpture as 'resurrection — the resurrection of a tree in a different form'. The whiteness of alder wood, for example, turns red quickly after it's been cut, as the sap is exposed to the light: this is a quality of that species he has welcomed, drawing on the alchemical symbolism of the colours in the sculpture *Red and Black*, for example. In Poland, he discovered that the alders with which he was working were planted on a World War I battlefield, and were growing in old shell craters: the piece gains chthonic energy from this connection providentially offered by the reddened timber. He likes to follow where trees lead, metaphorically to work with the grain, not against it, as he responds to the continuing life within the tree, even if it has fallen or been felled.

Wood can express mortality, especially in a Christian culture which stands under the sign of the cross, the gallows tree on which Christ died. Trees mark graves in the mythological stories of the Greeks as well as in the rich store of imagination and insight offered by fairy tales, which David Nash perceives as 'potent remnants' of ancient wisdom. In the Grimm Brothers' 'Cinderella', the heroine waters the tree on her mother's grave with her tears until, one day, it shakes down the dresses she will wear to the ball. In 'The Juniper Tree', the mother dies after she has eaten juniper berries and is buried under the tree; her son, maltreated and eventually murdered by the wicked stepmother who succeeds her, is served up for dinner and eaten unknowingly by his father. But his sister gathers up the bones which their father tosses under the table, and buries them in turn under the juniper tree, and the boy is resurrected from the branches as a beautiful, magic bird, who flies about and sings a song which spellbinds everyone who hears it:

My mother, she slew me,

My father, he ate me,

My sister she gathers up my bones . . .

At the end of this most macabre and potent tale collected by the Grimm Brothers for their famous anthology, the bird drops a millstone on the stepmother's head, and in the fire that burst out around the tree at her death, is resurrected as a child again. So the juniper tree presides over death and rebirth as the uncanny sequence of events unfolds. Using transformational magic similar to the wonders of fairy tales, art through representation often seeks to reverse the sentence of mortality.

Windblown or otherwise condemned trees, especially the ancient giants David Nash uses, symbolise transience too. But wood also contains the idea of renewal: after all, the cross of Christianity signifies the faith's promise of eternal life. Alchemy rang a magical variation on this theme of sacrifice and resurrection, when, in an image which appeals to David Nash, its adepts portrayed the old, naked Adam as 'prime matter', dying so that the philosophical tree of wisdom could be born from his loins.[6]

At a practical, literal level – the all important plane of stark survival – wood also sustains much other life, through the heat it gives when it burns, the shelter it provides, and the myriad further uses it offers. Nash's sculpture constantly alludes to these: the curved *Serpentine Vessels* on the floor, arranged like a flotilla of fishing boats, the bowls and spoons and vessels for nourishment, steps and ladders, hearths and stoves, the massive, weathered, *Ancient Table*. These sculptures point to common artefacts of daily life, and to the craft-work of ordinary survival.

In *Faust*, Goethe's great dramatic epic about the limits of the human quest for knowledge, Mephistopheles mocks Faust and his scientific investigations; the devil deriding the man for nourishing his mind on dead things, for killing the subject of his inquiries in the attempt to discover the principle of life, to know vital energy:

> To docket living things past any doubt
>
> You cancel first the living spirit out:
>
> The parts lie in the hollow of your hand,
>
> You lack only the living link you banned.[7]

David Nash, by contrast, pursues his knowledge by respecting the life of the wood. The art he practises unites with the flowing metamorphic powers of nature to make different shapes, new organic arrangements; he participates in the daily miracles of transformation around him. The mineral ramparts around Blaenau are regularly drenched by the higher than average rainfall (over 300 centimetres a year – David Nash laughs that every Atlantic cloud makes for Blaenau), Welsh streams spring down the fields and hills from the mountains of Snowdonia, mosses grow in deep green velvet cushions through the oak and birch woods outside the town which provided the fallen boughs and driftwood he needed when he was too poor to buy materials. As an artist, he travels all over the world, from northerly Hokkaido in Japan to Tasmania in the farthest southerly reaches of the inhabited world, and he draws his

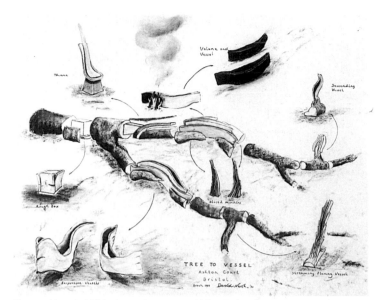

Tree to Vessel, *1990, charcoal on paper, 135 × 162 cm*

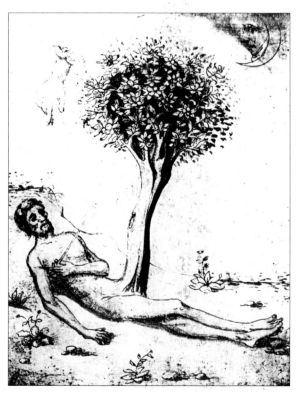

Adam as prima materia *with the* arbor philosophica *growing out of him, from the 14th-century 'Miscellanea d'alchimia'*

inspiration from the different properties of landscape and tree he finds in each place: the mizunara (water oak) of Japan, the Australian gum tree, the Californian redwood, the palms and pines of Catalonia, and the Polish alders. As he puts it, he 'weaves the elements of earth, air and water together', responding to their mix and balance in different places, and assimilating himself in this to the trees he uses as his raw material. He quotes Lao Tsu on the primacy of nature, and appears to be reminding himself of its mystery and unknowability:

> The way is forever nameless.
> Though the uncarved block is small
> No one in the world dare claim its allegiance . . .
> Only when it is cut are there names.
> As soon as there are names
> One ought to know that it is time to stop.[8]

David Nash does carve, cut, hew, scrape, saw, split and twine – but he acts in symbiosis with the wood, and with time. Sometimes, he adds fire, too: the blackness that results from the charring of wood returns it to a kind of primordial antiquity, recalling the alchemical *nigredo*, or blackness of origin, the first state in the quest for the Philosophic Stone.[9] Interestingly, Rudolf Steiner reversed the alchemist's traditional scale of values, and considered black carbon the highest goal – not gold. Since *Black Dome* (1986), and *Threshold Column*, David Nash has taken further his exploration of 'purging by fire', probing the meanings burning can yield; for the majestic *Light and Black Gate* in Hokkaido, flames lit up the two different signs of the cross carved into the wood and then left a permanent trace of charring.

Carbon is the vital ingredient in compost and organic growth: in this sense it is the lifestuff of nature's cycle. Primo Levi, himself a chemist with a powerfully poetic and philosophical mind, concluded his brilliant study, *The Periodic Table*, with an eloquent meditation:

> Carbon is the key element of living substance . . . Every two hundred years, every atom of carbon that is not congealed in materials by now stable (such as, precisely, limestone, or coal, or diamond, or certain plastics) enters and reenters the cycle of life, through the narrow door of photosynthesis. Do other doors exist? Yes . . . they are doors much narrower than that of the vegetal greenery . . . so . . . one can well affirm that photosynthesis is not only the sole path by which carbon

Redwood, 1989, Bear Gulch, California

Oak, 1991, Radunin, Poland

Palm, Ironwood, Plane, 1995, Barcelona, Spain

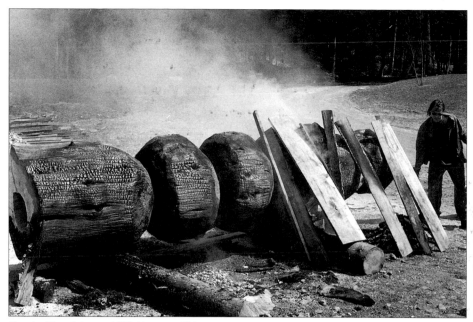

Charring Pine Column, 1993, Vermont, USA

becomes living matter, but also the sole path by which the sun's energy becomes chemically usable.[10]

Through the breathing of trees, the stuff of life does its work of transformation and quickening. Aristotle used the Greek word for forest and wood – *hyle* – for matter itself, the stuff from which living things are made.

The ancient Chinese, sensitive before modern science to the magical and fundamental relation of wood to life, were wise enough to count wood as a fifth element, and in David Nash's work it acts as the connective tissue between the other, Western elements. Earth, air, fire and water bind with wood to shape its life and its afterlife, too. He feels a strong sympathy with the tenacious energy of trees: 'Compared to minerals, they're close to our time, to our rhythm of life and death,' he says, showing a photograph of a muscly dead tree stump clasping an ancient rock, 'a young tree will start again, growing up and around the stone'. The sculptures continue to show independent vitality beyond the artist's control: their maker isn't setting himself up as a master of natural processes but as a catalyst and then a witness. Nash uses green rather than seasoned timber on purpose, so that it retains its own energy, splitting and warping and cracking and settling into a different shape after his intervention: 'I keep my mind on the process,' he says, 'and let the piece take care of itself'.

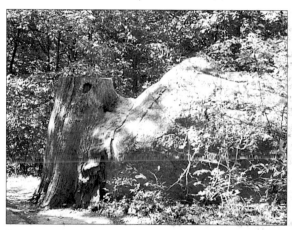

Stump and rock, 1983, Elephant Rocks, Missouri, USA

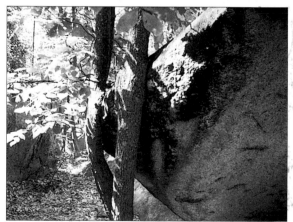

Young tree and rock, 1983, Elephant Rocks, Missouri, USA

Natural Disorder

His present, dynamic relation with wood as a material started, he recalls, when the *Nine Cracked Balls* asserted themselves, splitting open and 'grinning' at him. The cracked boxes began as smoothly planed cubes, but as the air leached the moisture from the wood, the sides bent and split along the wood's grain, making star shapes around knots in the timber: David Nash imposes form, but the material responds by loosening itself from the tight imposition of will.

Wooden Boulder, chopped from the heart of an oak in 1978, was one of his earliest Welsh pieces, and it reveals how deeply Nash wants his sculptures to continue to belong to the cycle of growth, mutability, renewal. He first placed it in a Welsh stream high on a hillside near Blaenau, and left it to be carried down with the current; he revisits it in different weathers and seasons, in its new position, chronicles its long stubborn voyage to the sea, helps it if it gets stuck (as it did, under a low bridge, in 1994), but otherwise lets it be. *Wooden Boulder* is a work which unfolds over time in his absence, alive through the continual flow and play of water upon it.

Yet while Nash explores the potential of natural processes, he also plays with natural law, often with gentle humour. *Wooden Boulder* looks natural – but it's a rock that can float, even bounce on the current. The artist, like the homeless soul who makes his house, upsets the so-called laws of nature, reveals the affinities of stone and wood. There's an analogy here, too, with the way he parries the lightless inertness of slate with his symbols of growth, with living timber. The surprise – almost the trick – is part of the satisfaction his work gives the viewer, who, out walking in the Welsh country-side, comes across this miracle, a wooden rock.

On a nearby four-acre plot of sloping, varied woodland in Maentwrog, the nearest village to Blaenau, David Nash is literally growing a series of works. Many will not be visible in their ultimately destined forms for another decade, some will not be complete until the artist is well into his seventies. The first sculpture David Nash planted, in 1977, was the *Ash Dome*, a circle of twenty-two ash saplings which he has bent and trained to swirl sideways and upwards in order eventually to form a natural domed enclosure. 'The question I had that led to the dome,' he says, 'was how does one have an outside sculpture that is truly of the outside, that engages the elements instead of resisting them?' The piece's literal rootedness also symbolises Nash's commitment to place. While

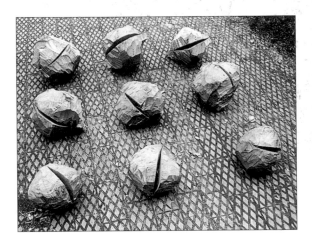

Nine Cracked Balls, 1971, ash, Capel Rhiw, North Wales

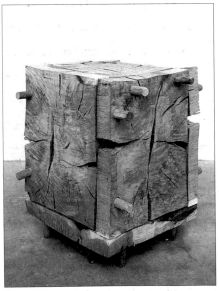

Cracked Box, 1990, oak, Capel Rhiw, North Wales

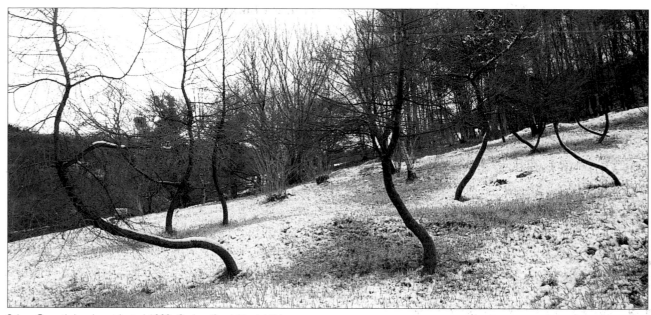

Sabre Growth Larches, *planted 1983, Cae'n-y-Coed, North Wales*

the *Wooden Boulder* is being carried away, the *Ash Dome* remains in place, only changing over time.

Since the *Ash Dome*, Nash has planted many more living sculptures, including a thicket-like Celtic hedge of sycamore and common maple, planted in thirty-three groups of three trees, twisting this way and that, in a restless rhythm. With a lovely clump of larches planted in 1983, the rhythm and musicality of the artist's design are intensified: they have been trained to swing out and up like dancers turning rather than shooting straight up as is their way. Further off, complementing the closed form of the dome, Nash is growing an open bowl of spread-eagled oak, on a slope so that it tilts towards the sky like a receiving radio or satellite dish. Living ladders of sycamore, and irregular squares of birches, recalling the form of the cracking boxes, are also thriving in this earth work, this artist's experiment with forms over time.

The hillside, with its various green, growing monuments, recalls the pioneering gardens of Chinese philosophers, with their cultivated shapes integrated in wild settings. More particularly, it shares the atmosphere of outdoor temples, like the huge, open circular platform of the Temple of Agriculture in Peking (where the Emperor made sacrifices each spring to bring a good harvest), which stands near the great pagoda of the Temple of Heaven, itself held up by a single central 60- to 90-metre column which was carved from a trunk sledded and slid on ice-bound rivers three thousand

miles from Yunnan to the capital. Nash was pleased by this reference: he has created a natural temple to pay reverence to nature itself. It's not surprising that his work has attracted interest and deep admiration in Japan; he first exhibited there fourteen years ago, and has recently held a major travelling show.

The convergence of Oriental and Occidental approaches to landscape occurs so early in the history of gardening, that David Nash could almost be said to be working in a little-known tradition of abstract art in the British Isles. In 1690, the architect and theorist William Temple introduced a concept of beauty as 'natural disorder', 'studied irregularity'. He called it 'sharawaggi' after the Chinese (though the word has never been traced back). Sharawaggi became a highly cultivated aesthetic principle in the eighteenth and nineteenth centuries, recognisable in the work of the greatest innovators of Romantic environmentalism, like Horace Walpole and Capability Brown.[11] The aesthetic demanded wilful human interference in the landscape, but it also required that the passage of the hand, the hoe, the billhook and the secateurs should be effaced in the final impression; as the scenery grew, the artists and impresarios made a pretence of disappearing altogether from the scene.

The pursuit of a natural geometry of living plants was not informed by metaphysics when practised by the famous creators of the wild English garden, but there quickly developed alongside, in

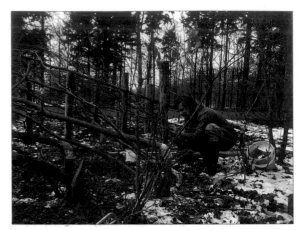

Working on Divided Oaks, *Hope Velwe,. The Netherlands*

Divided Oaks, *1985, charcoal on paper, 39.6 × 87 cm*

Bramble Ring, *1984, Cae'n-y-Coed, North Wales*

literature and the visual arts, a strong sense of the immanent mystical forces in such man-made 'natural' scenery. In France, when Baudelaire wrote his famous sonnet 'Correspondances' (1857),[12] he was influenced by the theory of sensory unity which he had found in the work of the Swedish mystic Emmanuel Swedenborg (1688-1772); Swedenborg had also influenced William Blake, the English poet and artist who found holiness in living things, 'awful mystery' as well as innocence, tenderness and love. Wordsworth's 'Tintern Abbey' (1798) is possibly the most famous, English culmination of this approach.

The relationship between David Nash's sculpture and this tradition is not as fanciful or far-fetched as it might seem. A strain of occult natural mysticism also informs the work of German Romantics, including the poet Goethe, and it then flows into the work of the theosophists. Rudolf Steiner, though he opposed the theosophists in many areas, also felt they were the only group who could understand his thinking. Steiner edited Goethe's scientific works and founded, in Dornach in Switzerland, the Goetheanum, a temple where mystery dramas like Goethe's *Faust* are still performed. David Nash has been closely involved with Steiner's anthroposophical thought for a decade: he and his wife Claire Langdown, also an artist – a painter – helped found a Steiner school in Snowdonia eleven years ago, and have been involved ever since. Claire has been teaching in the school for six years.

The east wall of the former Welsh chapel which now doubles as his studio and exhibition space still bears the inscription, in Welsh, which was painted there when it was used for worship: 'Sancteiddrwydd a weddai i'th dy' ('Sanctify this house with prayer'); Nash says, 'I'm trying to do that, with my work'. He also acknowledges the fundamental inspiration of the *Tao Te Ching*'s teachings, including the poem's warnings against rigidity and the thirst for mastery:

A man is born gentle and weak.

At his death he is hard and stiff.

Green plants are tender and filled with sap.

At their death they are withered and dry.

Therefore the stiff and unbending is the disciple of death.

The gentle and yielding is the disciple of life . . .

A tree that is unbending is easily broken.[13]

The Forest Within

Modernism inherited Dada and Surrealist discomfort with any kind of religious leanings, and writings about contemporary artists often evade the issue of their beliefs. This discomfort has obscured the crucial links between art and scientific explorings, between the faculty of sight and inner vision, between alchemy, numerology, religious and artistic inspiration. Joseph Beuys himself, the anarchic genius of the post-war conceptual avant-garde, began by making crucifixes, and though his later sculptures abandon clear Christian images, his use of bodily relics, like his own nails, adapt Christian sacramental tropes to art – sacrifice, burnt offerings. Beuys familiarised the public with the figure of the shaman, who abolishes the distinction between scientist and artist; he claimed Newton as well as Goethe as forebears, and turned performance and installation into rituals opening up knowledge, initiating the viewers or the participants. 'In shamanism', said Beuys, 'initiation comes through simulation of death. With it comes a closer relationship to matter, matter designated specifically as a transmitter of energy through selection, impregnation or infiltration . . .'

The figure of such a mediator, who can effect a magical reconciliation between nature and culture, between what is wild and what is human, haunts twentieth-century thought from distant roots in religious and secular narrative. Nash wants to abolish the difference between art and science, and this role as an intermediary corresponds to the work of diagnosis, initiation and discovery undertaken by a healer.

The early legends and romances tell of wild men – and women – who live in the forests on shoots and berries, are covered in hair like animals, and enjoy a closer relationship with the instincts, the passions, and pleasures: men such as Enkidu in the Babylonian *Epic of Gilgamesh* and Orson, the bear-man-cub, in the medieval romance *Valentine and Orson* who inspired such figures as Mowgli in Kipling's great *Jungle Books*. These heroes may be captured by passing hunters and brought into the city to be tamed, but this is only one level of meaning in such tales; alongside the descriptions of this desirable, civilising process, the stories often sound an elegiac note for the loss of the organic unity of all living things.

David Nash, like the mediating figure of the wild man, brings nature into the city – his temples aren't only exterior, rooted, slow time pieces, but sculptural statements for interior exhibition. He

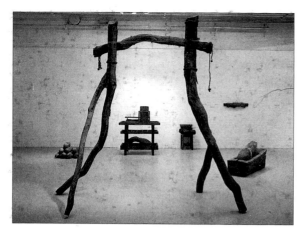

Roped Arch, 1971, installation at 'Sixty Seasons', Third Eye Centre, Glasgow, 1983

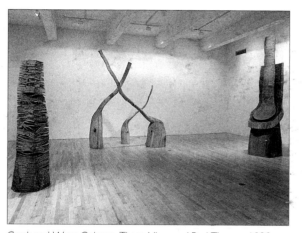

Crack and Warp Column, Three Ubus and Red Throne, 1990, birch, beech and redwood, LA Louver Gallery, New York.

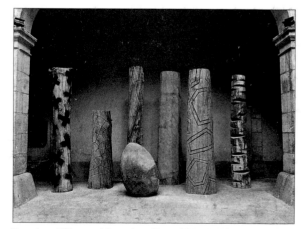

OVERLEAF: Congregation, 1993, Capel Rhiw, North Wales

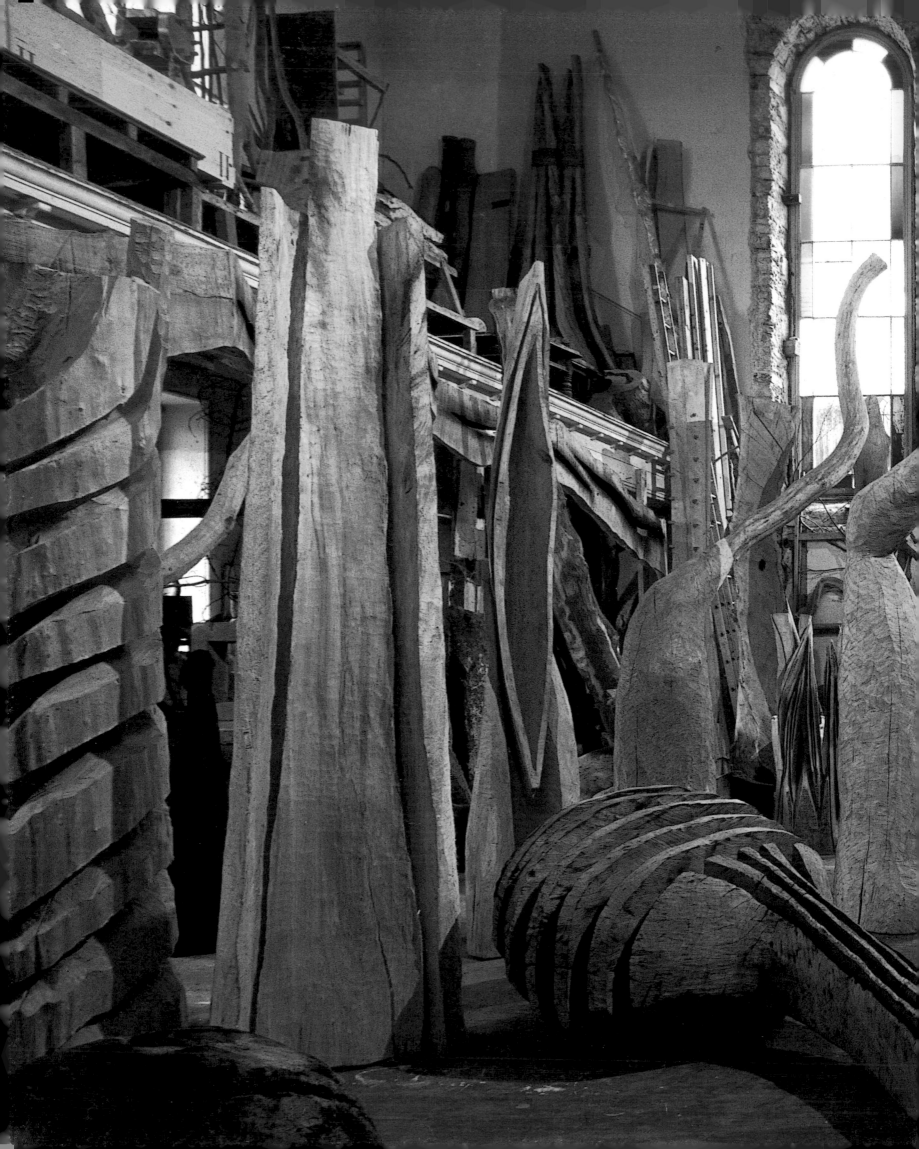

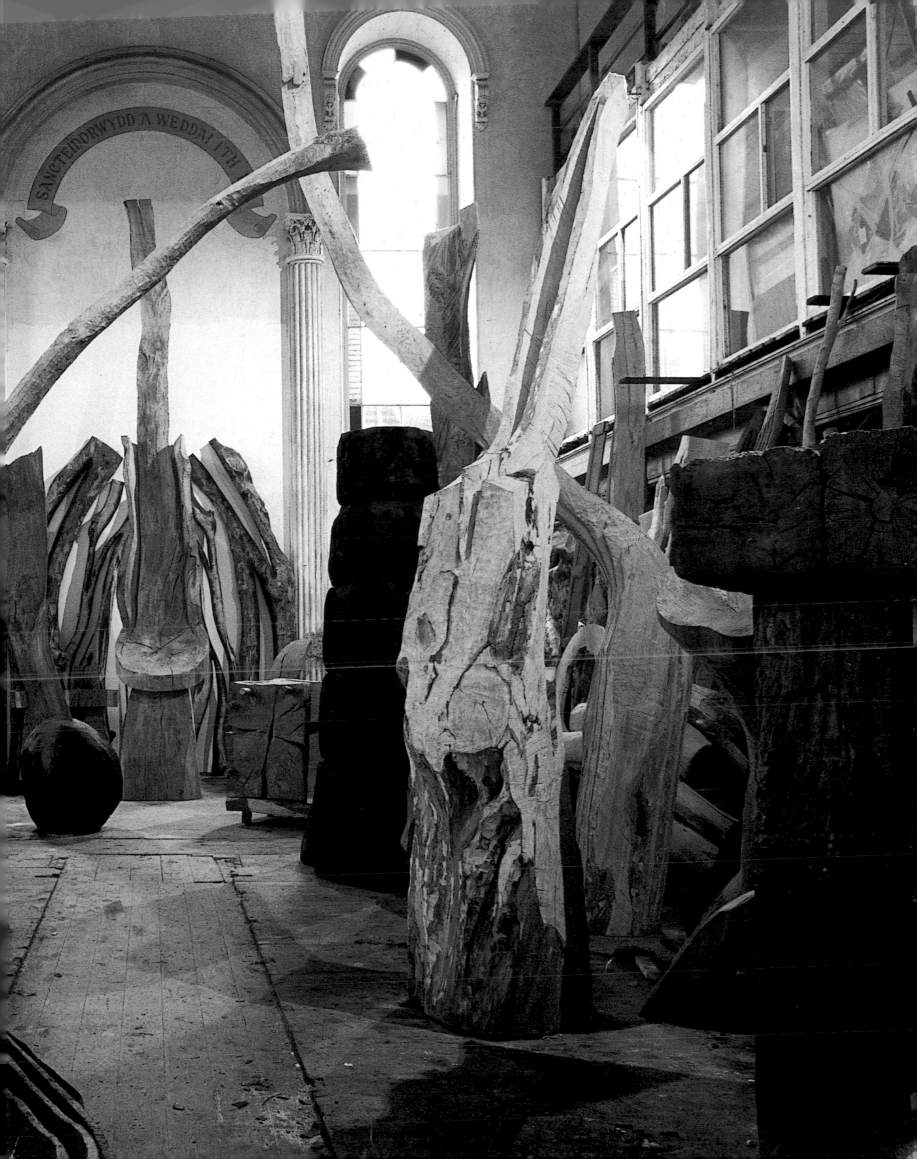

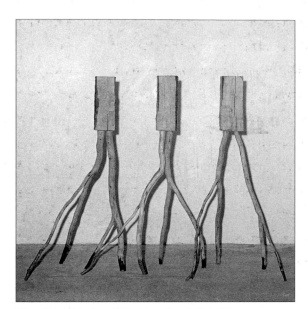

Three Dandy Scuttlers, *1976, oak and beech, Capel Rhiw,
North Wales*

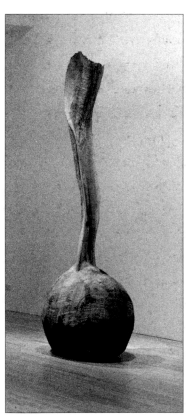

Comet Ball, *1990, elm, Capel Rhiw,
North Wales*

works outdoors, but brings his art inside, often with an acute awareness of how the pieces are still imbued with the elemental qualities of their natural habitat. In Australia, he noticed the ellipses cut into the bark of gum trees; he borrowed the form in his flame-like hollowed out vessels, only discovering afterwards that the Aborigines stripped the bark in this shape to make light fishing skiffs. He often groups the works to set up reciprocal rhythms: floor pieces like the curvy *Vessels* balance the soaring shaft of *Throne*, the graceful outstretched arms of *Arch*. Brought inside, wood paradoxically gains in presence, assertiveness, stature; certain exhibition settings, like the austere monks' refectory of the Abbey of Tournus (used during his 1988 residency), intensify the sense of reverence with which Nash infuses his work. But Nash's sensitivity to the sacred immanence of wood does not make him solemn. His indoor pieces are often filled with high spirits and laughter, as in the *Dandy Scuttlers* and *Running Table*. The humorous sexual allusions accept living creatures' ungainliness and vulnerability, as in the absurd, bulbous, leaning *Ubus*, for instance; but later sculptures celebrate masculine and feminine principles, with a deeper sense of awe, as with the pair of *Menhirs*, and the huge magnificent *Throne*, which makes another pair with *Veil*, the charred column enclosing an inner hollow, a calyx to the *Throne*'s pistil.

Among predecessors whom he admires, Nash naturally includes Brancusi, who explores with such formal austerity the sexuality of pillar, of ball, of egg, of blade. He occasionally refers to David Smith, another sculptor who understood soaring structures, and who never avoided joyful, even playful juxtapositions of shapes. Nash also reveres Matisse, a perhaps surprising choice, but a revealing one. Matisse's immersion in matter is total and full of sensuous delight, but never crudely carnal: he too refuses the division of soul and body, the spiritual and the material.

Being a man of gentle modesty, Nash resists the notion that an artist like himself can become a shaman. He isn't a believer in any conventional way, either, but he is committed to spiritual exploration. His dominating tendency is to conjure connections that absolve conventional polarities — chief among them the polarity between nature and culture. His first towers were soon followed by arches and bridges, both symbols of joining. He has since made ladders from single boughs, cloven and reconnected by the rungs; and carved steps into a still rooted dead trunk, rising skywards to

convey, by a different image, the reconciliation of ground and air. The need for reconciliation inspires all these versions of hyphens: a tower, a ladder, a tree, a menhir, as he points out, ascend and descend at the same time, connect earth and sky without preference for the state above or the state below. The uncompromising force of *Comet Ball*, with its flare of tail, both hurtles downwards to touch base and appears to be on the point of soaring towards heaven. Nash has also interwoven contrasts between cold and heat, ascending and descending forces, fire and water, in the series of *Hearths* or *Stoves* which he has built from local materials in every place that he has worked – bamboo in Japan, mossy rocks in Wales, sticks and clay on the delta of the Maal in Holland, and even shards of ice on the banks of the Mississippi one rare winter when the river froze. He films these hearths, writing with twigs or other means to hand, the simple, eloquent plays on words: Hearth–Heart–Heat–Art. One icy winter, he lit a fire in a cairn-like stove he'd built on a ledge of rock beside the waterfall foaming into a rock pool where the frosted *Wooden Boulder* was resting. The fierce, volatile, fleeting conjunction of ice and fire pleased him profoundly, epitomising the elemental flux he celebrates in his art.

In Britain, as in much of the industrial world, loss of contact with natural processes has been accompanied by an increasing forgetfulness about the intertwined destinies of people and places, of the land and its inhabitants. The cult of the Sublime and its emphasis on the wilderness, on its grandeur and separateness, deepened the gulf; as men and women lost touch with the cycle of growth and decay, with biological change and seasonal tasks, nature came to be perceived more and more as a category apart, full of terror as well as beauty. From the nineteenth century onwards social and economic developments have seen increasing alienation of people from the nature that sustains and nourishes them.

The role of the forest in Romantic art as well as in philosophy, and in literature like fairy tales, reveals the changing relationship between human and plant life that has been evolving since the industrial and technological revolutions. As work takes people farther from the forest and its maintenance, the woods become an increasingly mysterious and threatening place, in which children are abandoned to die or little girls like Red Riding Hood are punished for their waywardness, until, under the influence of psychoanalysis, the forest ceases to be a real place, but becomes instead a symbolic interior of the soul,

the theatre of liminal initiation, where the adult self is tested, annealed and shaped. The protagonists of fairy tales are often woodcutters, and their daughters often the heroines, but in a world that has lost the memory of woodcutting and all it entailed in practical and material terms, the forest has become an imaginary domain, a magical reservoir of knowledge and power. Today, trees present in the work of an artist like Nash act upon the imagination in a two-fold movement: as reminders of nature in all its sensory actuality, and as allegories of spiritual rootedness and possibilities of growth.

The present need to repair the rift between natural and cultural processes has led to an impassioned ecological artists' movement in Britain. The group Common Ground, founded by Angela King and Sue Clifford, specifically undertakes to explore the arts' potential to heighten awareness of these issues. This is not conservation, but the dynamic participation of people in their landscapes. The group has successfully campaigned to place sculpture in forests, on clifftops, on beaches, to provide markers of 'local distinctiveness' for passers-by. Its leaflet *A Manifesto for Trees*, with drawings by David Nash, gives precious information, some familiar ('all trees should be protected'), some less so ('think carefully before you plant a tree' – nearly half of all saplings planted in cities die within ten years because their environment can't sustain them). The latter is borne out by Nash's *Sod Swap* for the 1983 British Art Show: he lifted a ring of woodland from Wales and exchanged it with a similar patch of London turf; the Welsh migrant, rich in twenty-six plant species, did not survive its two London sites, but David Nash still mows, London parks-style, the bracelet of poor urban grassland (only five species) growing on his land.

David Nash subscribes to Common Ground's philosophy, which differs in many respects from ecologists' emphasis on nature's autonomy and apartness, and their advocacy of nature as wilderness; his allegiance lies with the woodsman's wood, the agriculturist's garden. Some of his interventions in the landscape have a deliberate purpose: *Black through Green*, made in St Louis, consists of charred timbers laid to make a path which leads walkers safely through woodland infested with poison ivy.

Recently, David Nash has been edging into colour: the inherent Martian fire of raw alders' redness flared in contrast to the charred sootiness of oak in the eloquent floor piece *Red and Black*; Nash sees the red symbolising arterial blood with its powerful upward

and outward current, while the black represents the downward movement of the nerves: 'They keep each other in balance', he says. A few years ago, Nash harvested seed from the wild bluebells on his plot of woodland (and for those who have not seen a bluebell wood in flower, its blaze of deep cobalt to azure has no rival in any other wild bloom, except jacaranda blossom). He then drew, in pastels on canvas, a blazing *Blue Ring* to hang on the wall above another blue ring made of the seeds; the drawing dissolves materiality, for blue is the colour of space, of distance, of height and depths, while the blue of the seeds is also fugitive, turning white once placed in the ground as the seeds metamorphose into bulbs.

Nash never makes monumental, heroic earthworks, like the late Robert Smithson or James Turrell today. His work tackles trees of immense height and girth, but he is dedicated to 'low visibility', to that sleight of hand that removes the maker from the artefact. While David Nash clearly isn't a macho cultist from any point of view, he is nevertheless one of several male artists of his generation in Britain who have taken it as their task to rethink and repair the rift between humanity and nature, and who consequently work in and with the landscape. Richard Long, Hamish Fulton, Chris Drury, Peter Randall-Page and Andy Goldsworthy have developed a

double strand in this new, active, nature sculpture: they grapple with the sense of an immanent, overwhelming spirit in stone and tree, and, at the same time, acknowledge that human beings can't pretend they aren't part of nature, too, that they aren't present, making a difference. These artists record the traces of human foot and hand; they track our spoor in the landscape.

In conversation, Nash alludes to the 'cambium layer', the endodermis or skin that lies under the bark of a tree; this is the source of the wood's vitality, the matrix of its annual growth of bark and heartwood, yet it remains little known, rarely named, and hardly if ever invoked by the many poets of woodland and wilderness. Yet it is the vital link between the exterior and interior growth of the tree, and as such, can serve as an eloquent metaphor of Nash's sculpture, which mediates between nature and culture, matter and spirit, the lifestuff of the living tree and the fallen timber. As he says, characteristically, 'I've always considered spirituality to be immensely practical and physical'; this is what he means by 'the fact of sculpture'. For all his inwardness and sense of the sacred, David Nash's art is an art of earth, of the weather, rooted like the trees with which he works, made of the elements.

Notes

My thanks to David Nash for giving me his time; all quotations from the artist are taken from conversations during 1995 and 1996. (This essay is based on a text which was originally published in the exhibition catalogue *David Nash: Voyages and Vessels*, Joslyn Art Museum (Omaha, Nebraska), 1994.)

1 Quoted in Robert Lawlor, Sacred Geometry: Philosophy and Practice (London), 1982, p10.

2 Rudolf Steiner, *The Anthroposophic Movement*, trans Christian von Arnim (Bristol), 1993, p18.

3 Gottfried von Strassburg, *Tristan*, ed and trans AG Hatto, Penguin (Harmondsworth), 1960, pp78-81.

4 See Michael Evans, 'The Geometry of the Mind', *AA Quarterly*, vol 12, no 4, pp32-55.

5 David Nash makes his sculpture with fidelity to 'the language of wood', discerning the individuality of hornbeam, ash, oak, beech, not only in their look, their grain, their texture, but in their symbolic freight. Comparing the properties of oak and birch, he says: 'Oak is very male, macho, stubborn, grows slowly and rots slowly – little grows under it. Astrologically, oak is related to Mars. But birch belongs under the planet Venus, and is sacrificial, a pioneer in scrubland, actively encouraging other plants, letting light through and giving way to them; [it] drops its leaves and twigs and makes mulch, rotting very fast – so it's called the Mother of Oak.'

6 Carl Gustav Jung, 'The Psychic Nature of the Alchemical Work', in *Collected Works*, vol XII, p256.

7 Johann Wolfgang von Goethe, *Faust* (Part One), trans Philip Wayne, Penguin (Harmondsworth), 1984, p95.

8 Lao Tsu, *Tao Te Ching*, trans DC Lau, Penguin (Harmondsworth), 1963, chap XXXII, p91.

9 See Gareth Roberts, *The Mirror of Alchemy: Alchemical Ideas and Images in Manuscripts and Books from Antiquity to the Seventeenth Century*, British Library (London), 1994.

10 Primo Levi, *The Periodic Table* (1975), trans Raymond Rosenthal, Michael Joseph (London), 1985, pp227, 231.

11 See Jurgis Baltrusaitis, *Aberrations: Essais sur la légende des formes*, vol I: *Les Perspectives dépravées*, Flammarion (Paris), 1995, pp230-31; Nicolas Pevsner, 'Sir William Temple and Sharawaggi', *Architectural Review*, December 1949.

12 From *Les Fleurs du mal*, cf the first verse: *La Nature est un temple où des vivants piliers/Laissent parfois sortir de confuses paroles/L'homme y passe à travers des forêts de symboles/Qui l'observent avec des regards familiers*. (Nature is a temple where living columns/ sometimes emit confused words;/ there, man passes through forests of symbols/ which observe him with familiar looks.)

13 Lao Tsu, op. cit., Chapter LXXVI, p138.

FORMS INTO TIME
THE WORKS OF DAVID NASH

I want a simple approach to living and doing.

I want a life and work that reflects the balance and continuity of nature.

Identifying with the time and energy of the tree and with its mortality,

I find myself drawn deeper into the joys and blows of nature.

Worn down and regenerated; broken off and reunited;

a dormant faith is revived in the new growth on old wood.

(David Nash, 1978)

NINE LEANERS
CAE'N-Y-COED, NORTH WALES

1976

Nine Leaners *were made by splitting a fallen beech trunk along the grain with axe and wedge, halving the width, then halving it again in the manner of roofing slates split from a block. Their length was determined by the original length of the trunk, the number of pieces by how many could be split from it. Initial presentation/installation was where they were made – in this case leaning on a pole strapped between two beech trees.*

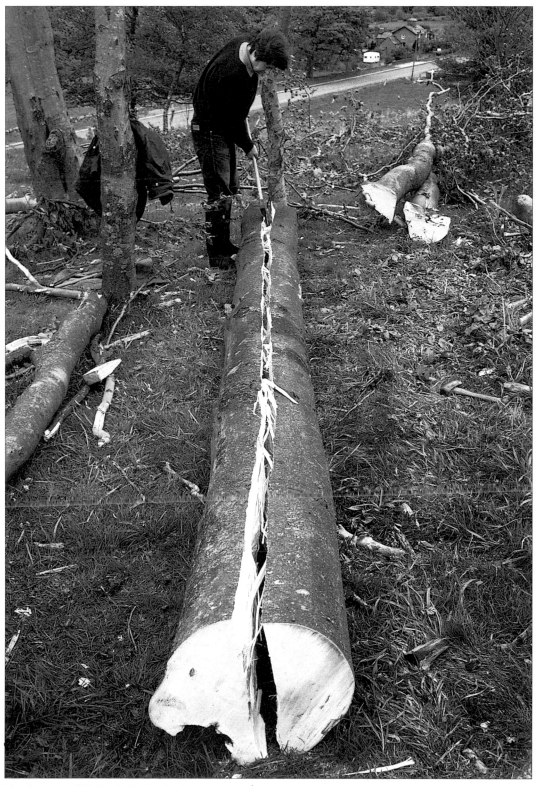

Nine Leaners, 1976, beech, Cae'n-y-Coed

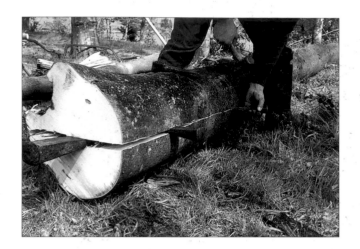 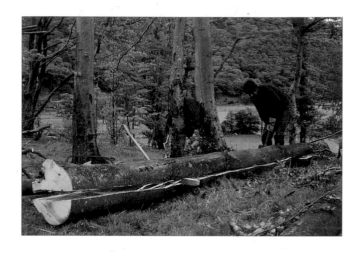

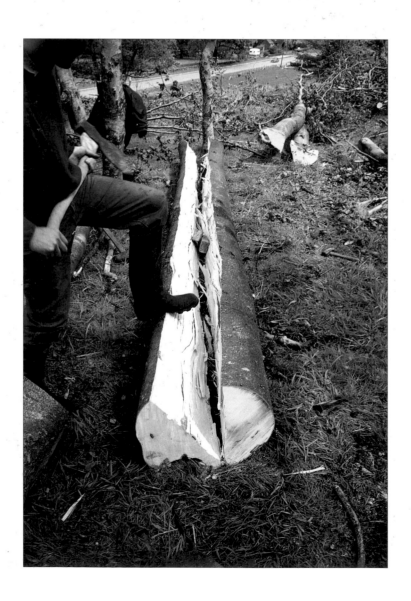

Splitting beech, 1976, Cae'n-y-Coed

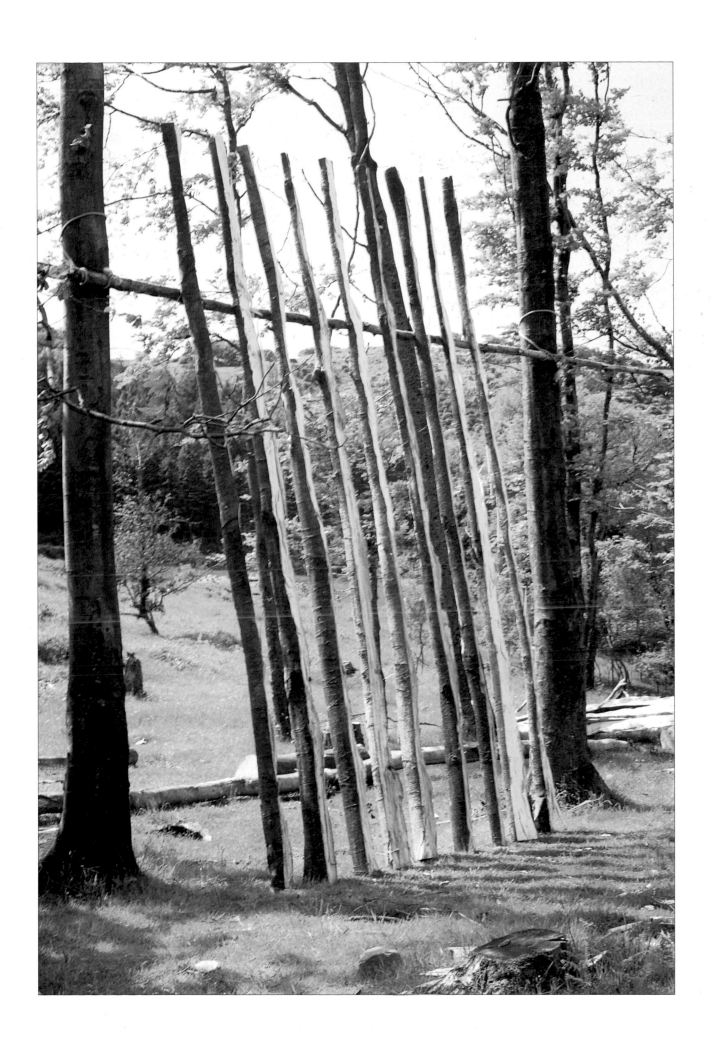

VESSELS

1985–

Vessel as a shaped and contained shape – its value being its empty space
Vessel as boat – a contained space in movement – a carrier, a space arriving

Passing a big gum tree on a dirt road in Australia I noticed a scar the size and shape of a boat, sharp end downwards – the image of an arrival. It felt like an idea arriving to take form, a vessel shaped space with direction from above to below – above being there, below being here.

This sense of ascent and descent through the vertical has been a recurring theme in my work since the towers and columns I made in the late sixties. The vessel image in the gum tree rekindled this interest. I later discovered that the boat scar was in fact just that: a native Australian had cut the outline of a boat and carefully removed the bark in one piece, stitched it into a boat and gone fishing. Such scars occur all over Australia.

This shape's gesture has inspired many other associations: not only is it a descending vessel, but an ascending flame; from the front, an open female, and from the side, an erect male. Above all, the shape is a magnification of the fibrous structure of wood, arranged to raise water by capillary action.

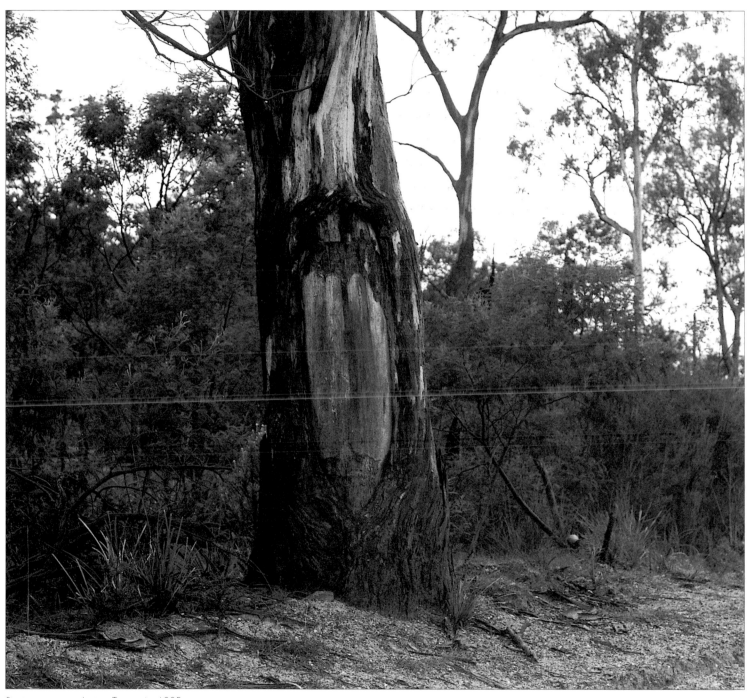

Boat scar on eucalyptus, Tasmania, 1985

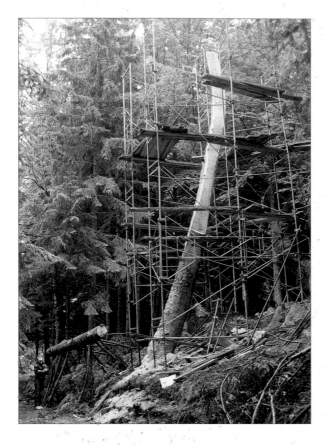

Carving pine, 1989, Ile de Vassivière, France

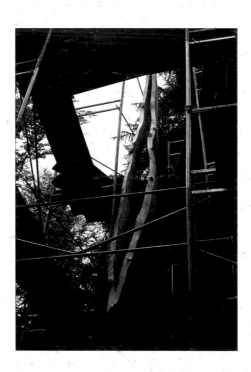

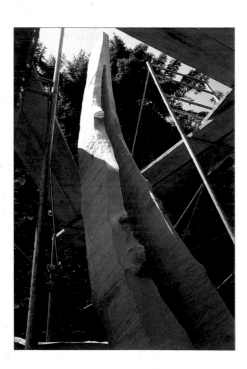

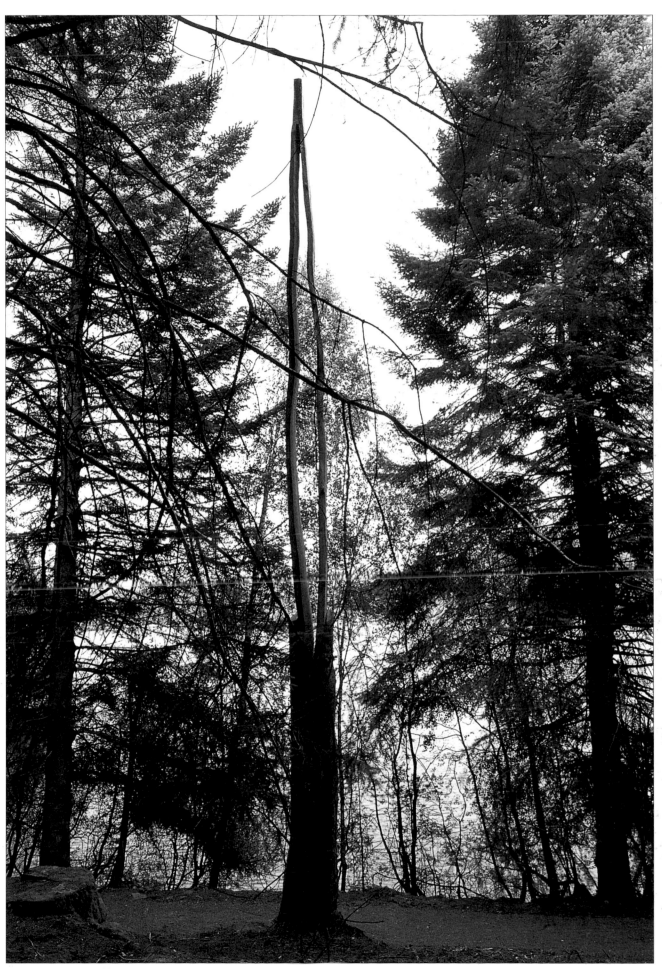

Descending Vessel, *1989, pine, Ile de Vassivière, France*

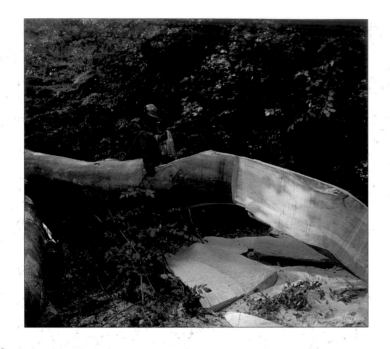 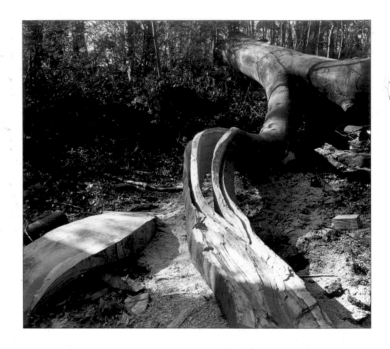

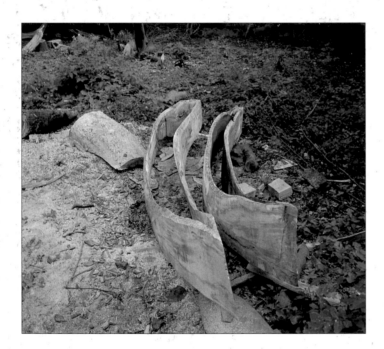 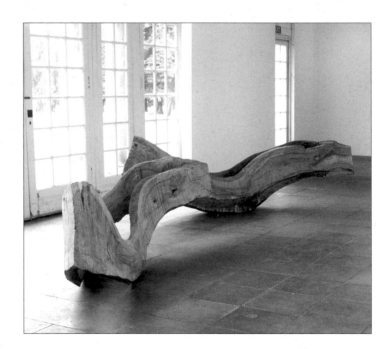

Serpentine Vessels, *1989, beech, Ashton Court, Bristol, England*

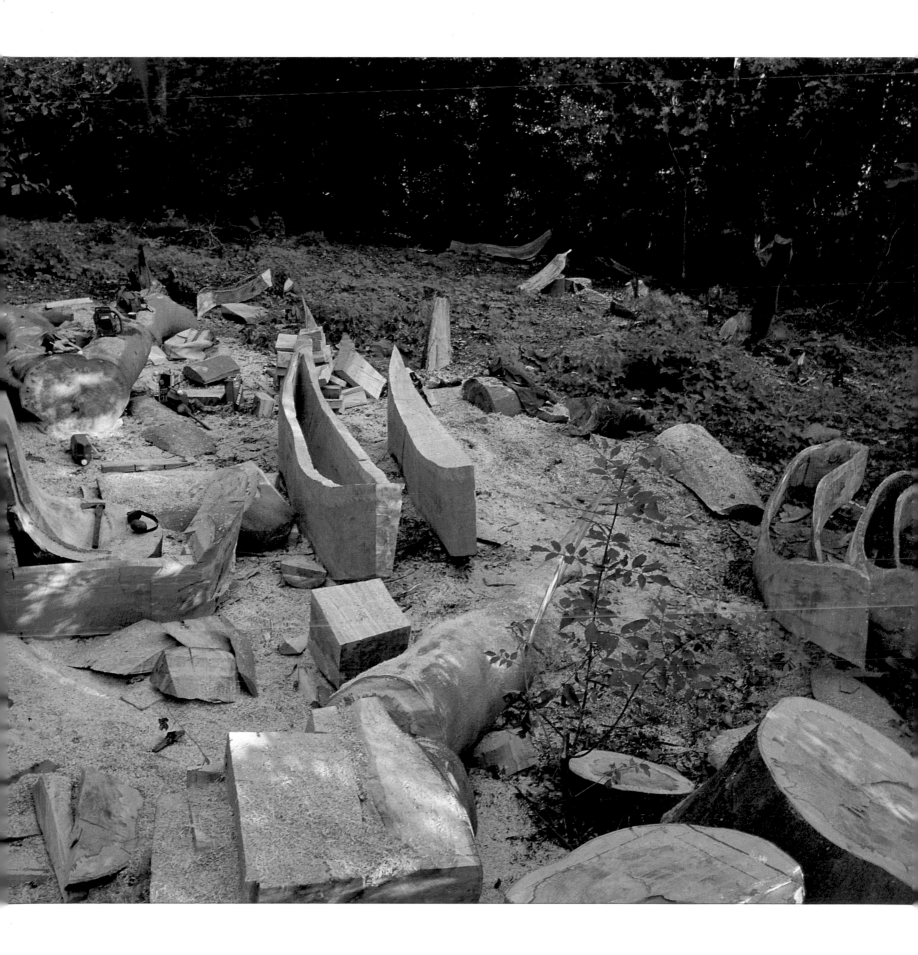

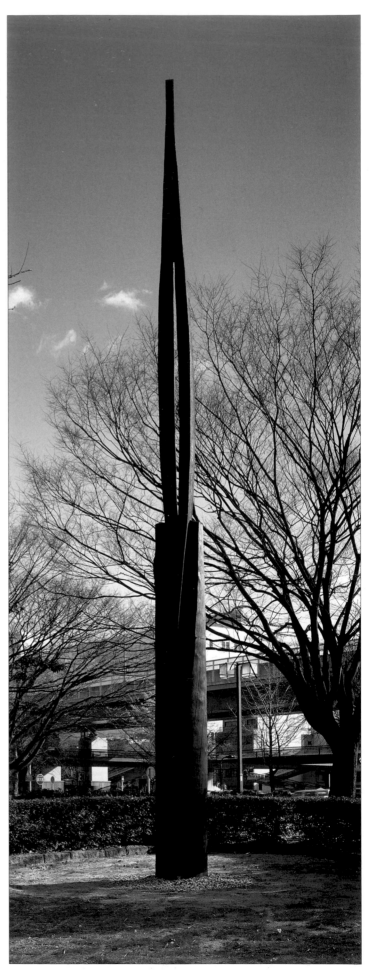

Descending Vessel, *1994, red pine, Nagoya, Japan*

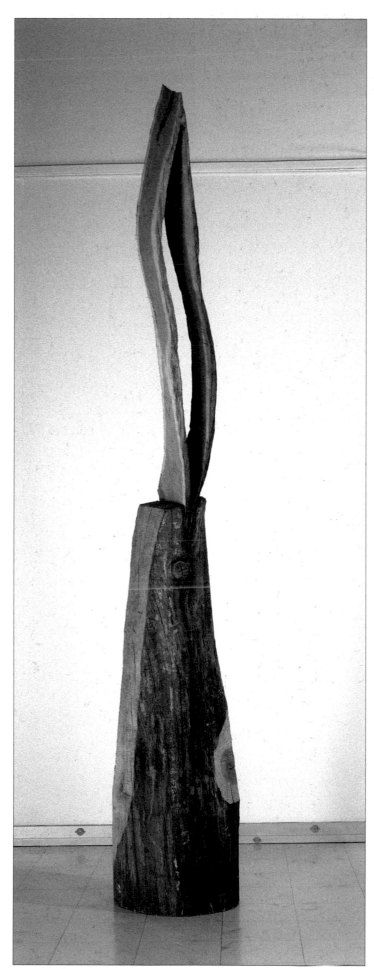

Descending Vessel, 1988, oak, Pierre de Bresse, France

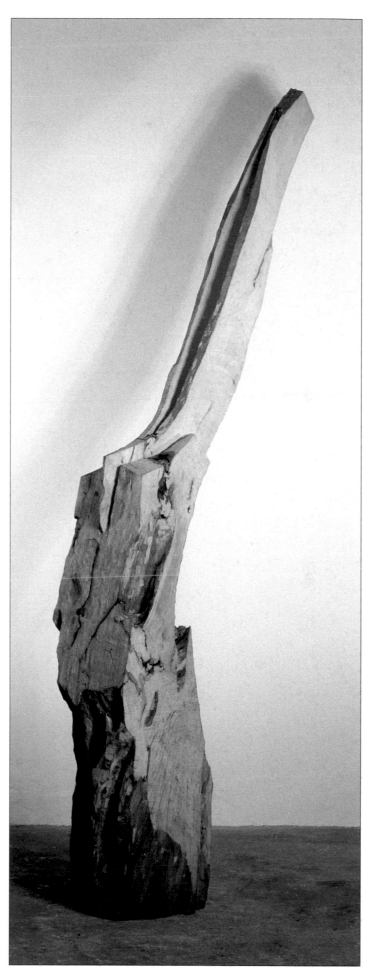

Descending Vessel, 1990-91, hornbeam, Gloucestershire, England

BLACK DOME
FOREST OF DEAN, ENGLAND

1986

When I was working as a resident sculptor in the Grizedale Forest in 1978, I often came across centuries old charcoal burners' sites – level oval spaces, barely discernible on the hillside, always with the same combination of plants. Presumably the carbon residue from the charcoaling process had leached into the soil allowing only certain species to flourish. These spaces, although nearly invisible, had a sense of human presence, an echo of ancient forest activity.

Eight years later I was one of a group of artists invited by the Forestry Commission to consider making sculptures in the Forest of Dean. The works had to be based on our response to the forest, sensitive to the environment, and accessible to the public. The Forest of Dean has a history of charcoal manufacture and remembering my experience in Grizedale I chose to make Black Dome. Ideally the sculpture would have been a mound of charcoal, but being so brittle this would not have survived 'public accessibility'. I therefore opted for charring sharpened sections of larch trunks.

To make a dome 8 metres in diameter and 1 metre high required nine hundred pieces of wood. Even working with an assistant, after the first day we had achieved only fifteen pieces. We thought we would be there forever. However, we improved our technique and increased our daily rate to over a hundred. A hole was dug, 50 centimetres deep, 8 metres in diameter, and partly filled with gravel for drainage. The nine hundred charred stakes were graded to form a dome, each piece wired to the next to prevent them from being pulled out. I had envisaged the sculpture re-integrating with its environment, rotting down gradually into a humus, combining with fungus and leaf-mould, with plants adding to the process of 'return'. Eventually a vestige of its original form would be left, a slight hump, a thirty to forty year process. I had also imagined grass and bracken growing around the dome. In summer, from the public footpath one would see the top of the dome above the bracken – black in green; in autumn, when the bracken had collapsed and turned amber, the whole Black Dome would be visible; and in the snow yet another variation would be experienced.

The sculpture trail quickly became far more popular than anyone had foreseen, radically changing the Dome's environment. A new path was made right up to the Dome and beyond it to the next sculpture to cope with the erosion caused by so many visitors. The Black Dome was transformed from a quiet reclusive object into a busy roundabout.

Something else that I had not anticipated was the public's delight in walking over the Dome. This initially produced a polished effect like a stroked cat but later the stakes began to shift disturbing the form. It needs to be made again in oak to cope with the attention.

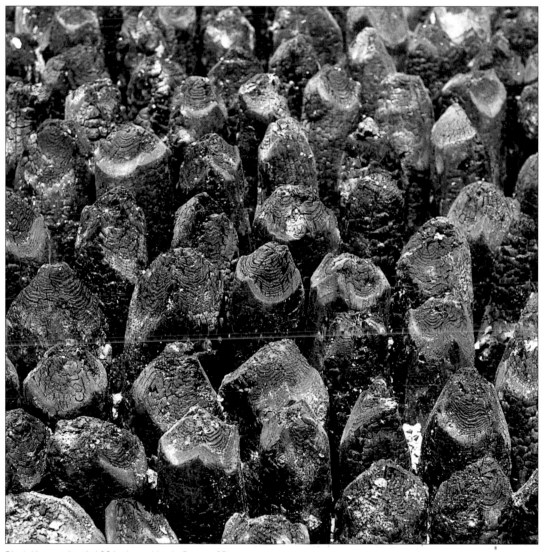

Black Dome, *detail, 1986, charred larch, Forest of Dean*

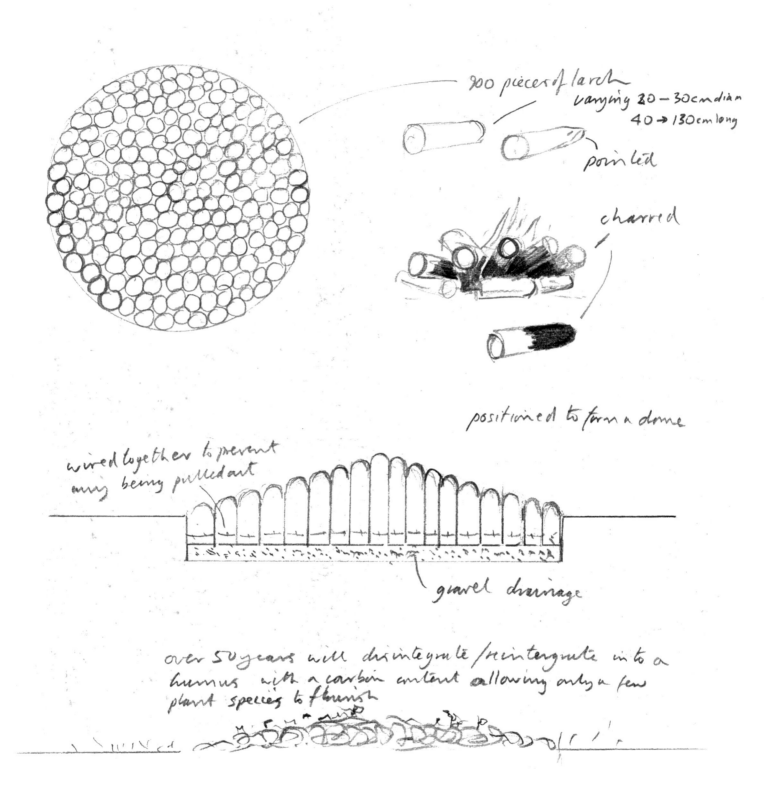

900 pieces of larch
varying 20 – 30 cm diam
40 → 130 cm long

pointed

charred

positioned to form a dome

wired together to prevent
any being pulled out

gravel drainage

over 50 years will disintegrate/reintegrate into a
humus with a carbon content allowing only a few
plant species to flourish

Black Dome, 1986, pencil on paper, 30.2 × 25 cm

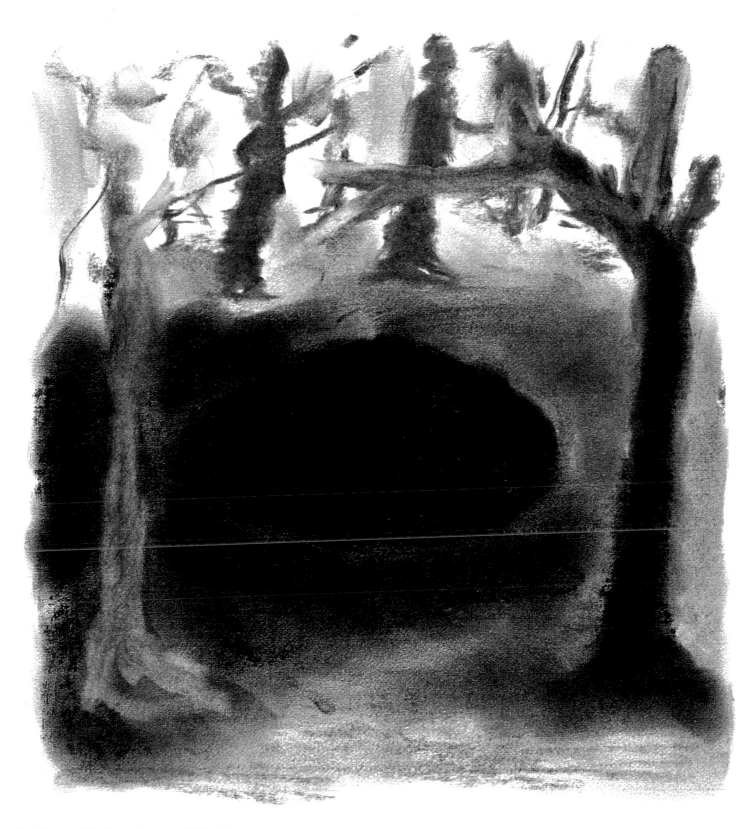

Black Dome, 1986, charcoal on paper, 30.2 × 25 cm

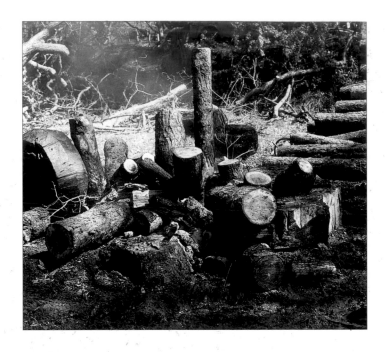
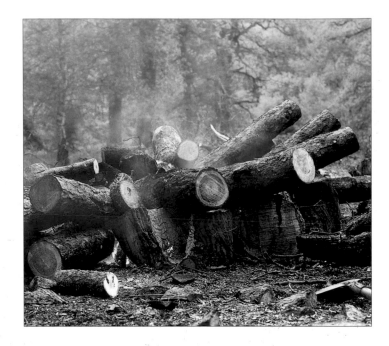
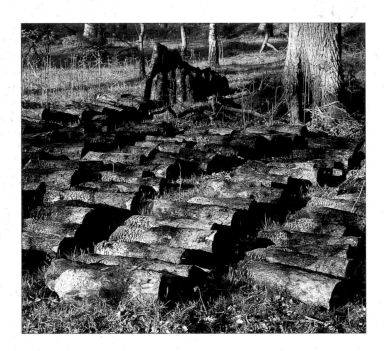
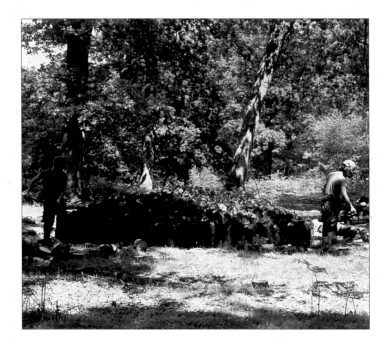

Preparing Black Dome, 1986, Forest of Dean

Black Dome, 1986, charred larch, Forest of Dean, summer

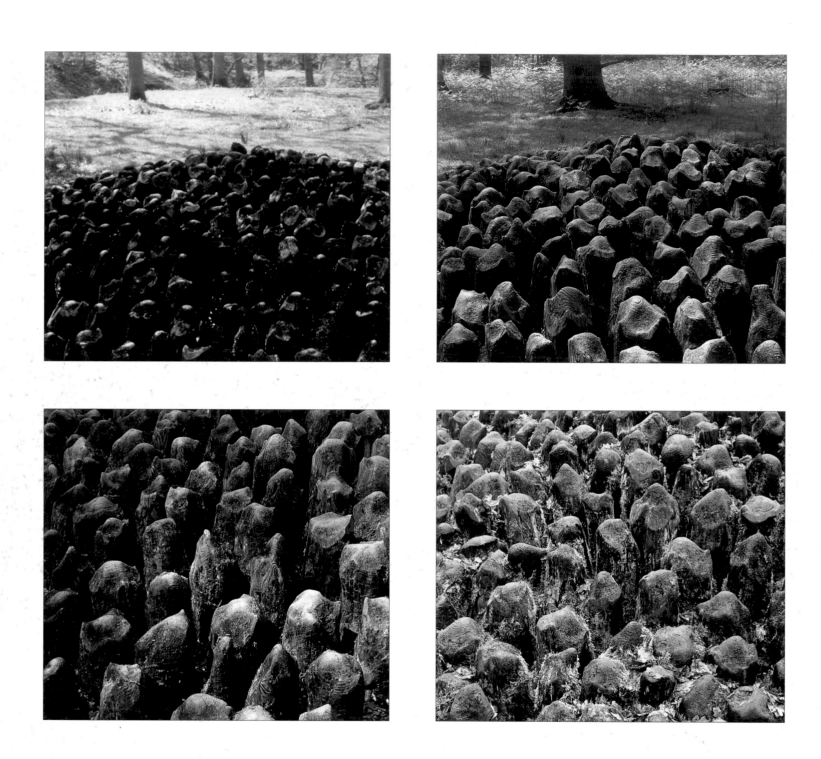

Black Dome, *details, 1986-95, charred larch, Forest of Dean*

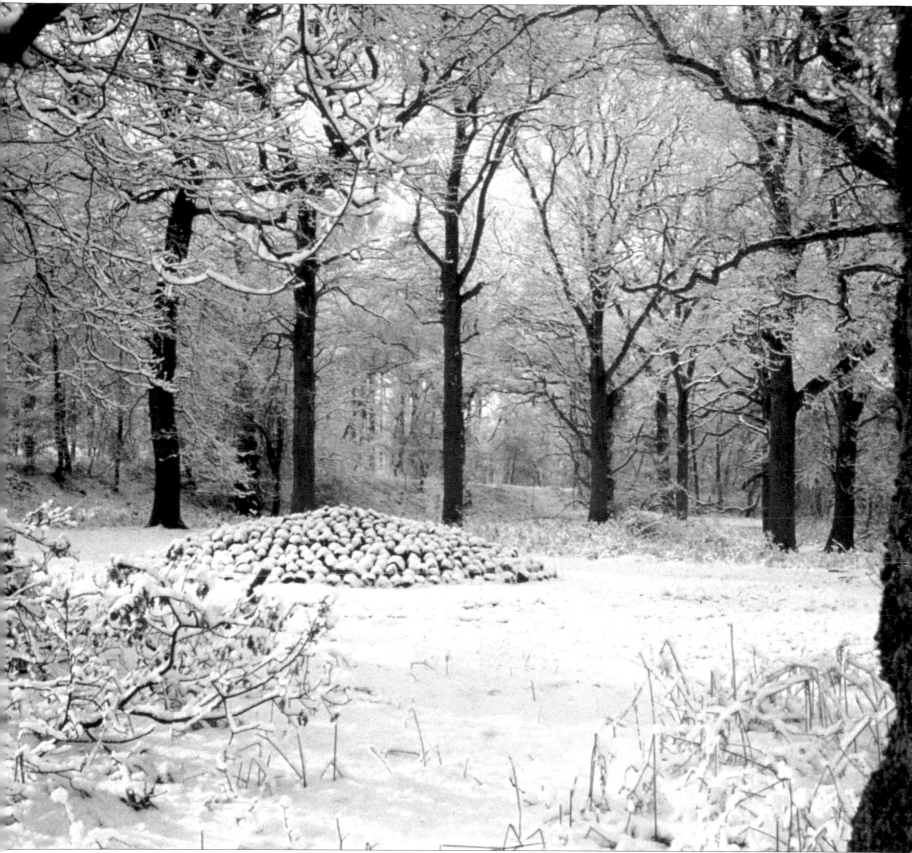

Black Dome, *1989, charred larch, Forest of Dean, winter*

BLACK INTO GREEN

ILE DE VASSIVIÈRE, FRANCE, 1989

The island in the Vassivière lake in France has a perfect environment and climate for moss. Carved and charred oak trunks and limbs were placed in a glade in a gesture of turning, radiating gradually from a loose sense of centre. Over time, the oak sections are becoming green, moss being naturally attracted to grow on a carbon surface.

Black into Green, detail, 1989, charred oak in moss, Ile de Vassivière

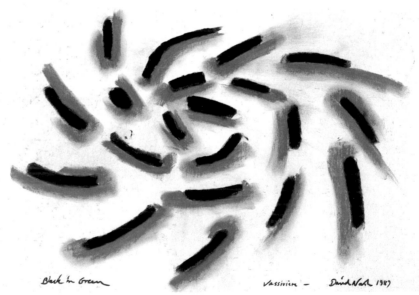

Black in Green, 1989, charcoal on paper, 45.8 × 63 cm

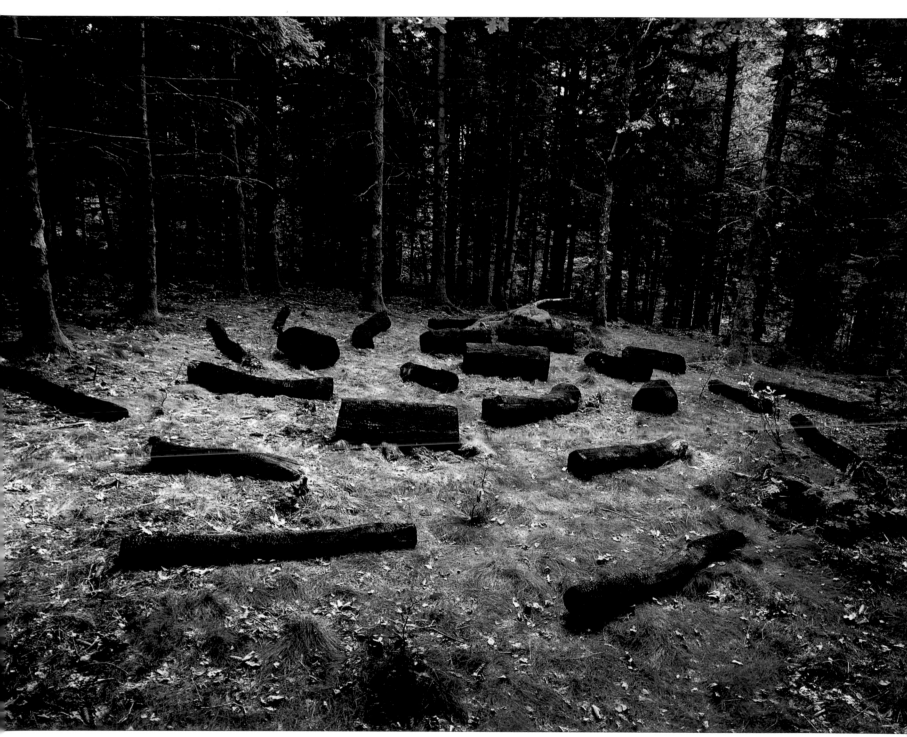

Black into Green, 1989, charred oak in moss, Ile de Vassivière

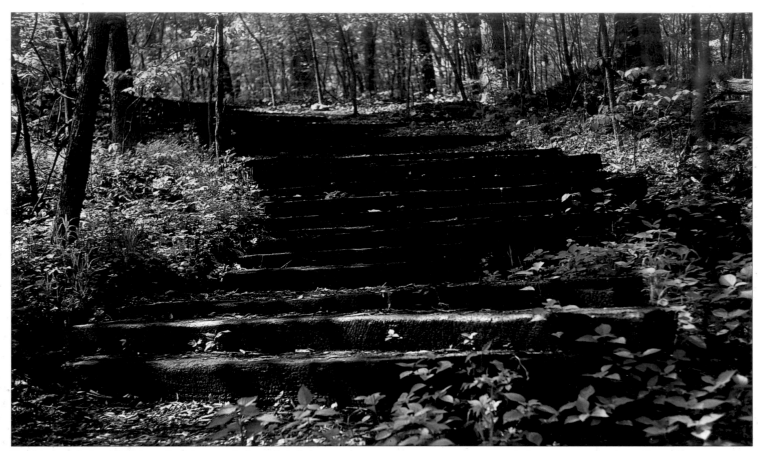

Black through Green, 1993, charred oak, Laumeier Sculpture Park, St Louis

BLACK THROUGH GREEN

ST LOUIS, USA, 1993

*The opportunity to work with the experience of peo-
ple walking over the charred surface of the Black
Dome came in St Louis. Four artists were asked to
make proposals for environmental works at the
Laumeier Sculpture Park. On a path I found wooden
railroad ties that acted as sporadic steps down a
slope, rotted and in need of replacement. The path
wound down through woodland with a dense green
ground cover – mostly poison ivy. My proposal was to
replace the steps with much longer (5-metre) oak
timbers charred black, their length extending beyond
the width of the path into the undergrowth. Walkers
would erode a path down the centre of the steps
keeping away from the poison ivy and leaving the
ends untouched – Black through Green.*

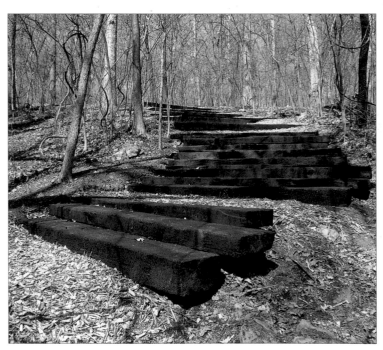

Black through Green, 1993, charred oak, Laumeier Sculpture Park, St Louis

48

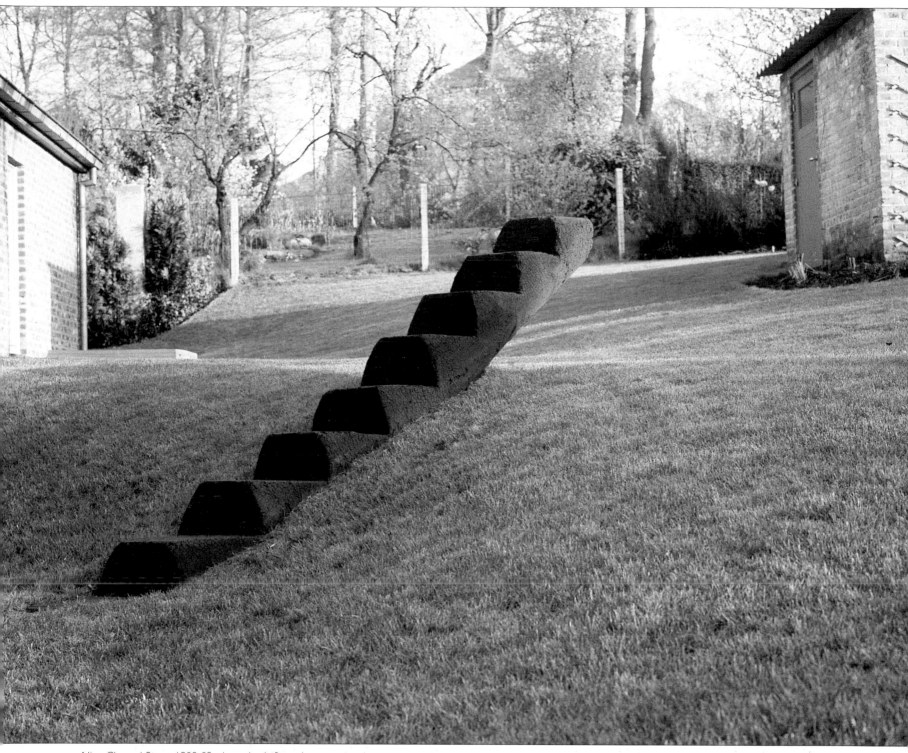

Nine Charred Steps, 1988-89, *charred oak, Brussels*

NINE CHARRED STEPS

BRUSSELS, BELGIUM, 1988-89

Working with the landscaping of a new garden in Brussels, an oak trunk was carved and charred to make a flight of steps extending beyond their functional use.

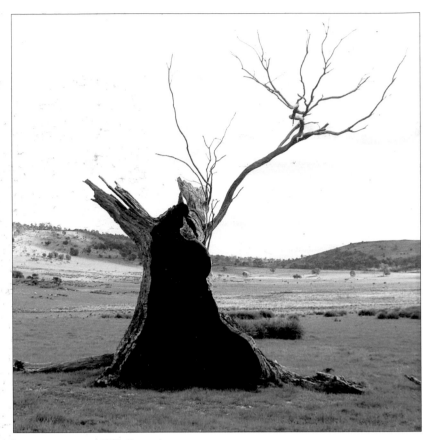

Burnt out gum tree, 1985, Tasmania

THRESHOLD COLUMN

LLANDUDNO, NORTH WALES, 1990

There is an Odilon Redon lithograph of a woodland scene, in the distant centre is a hollow tree. Its deep black hollow is drawn as a perfect triangle and the viewer is drawn to and into that space. There are many such burnt out hollow trees in Tasmania. The black of their interior is in sharp contrast to their exterior and environment giving a sense of a vast space beyond the entrance to the hollow. Threshold Column was made in response to these observations.

With wood sculpture one tends to see 'wood', a warm familiar material, before reading the form: wood first, form second. Charring radically changes this experience. The surface is transformed from a vegetable material to a mineral — carbon — and one sees the form before the material. The sense of scale and time are strangely changed, the charred form feels compacted yet distanced in an expanded space. Rudolf Steiner spoke about human responses to carbon being on two levels: the feeling and the thinking. The feeling instinct — connected to one's soul — is repulsed, withdraws; while the thinking instinct — connected to one's spirit — is attracted and advances. These two simultaneous experiences vie with each other.

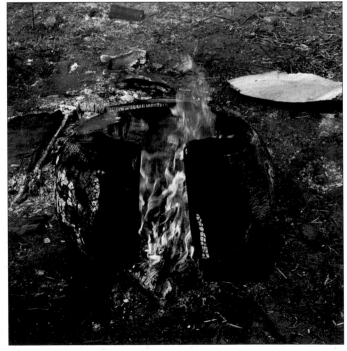

Charring elm ring

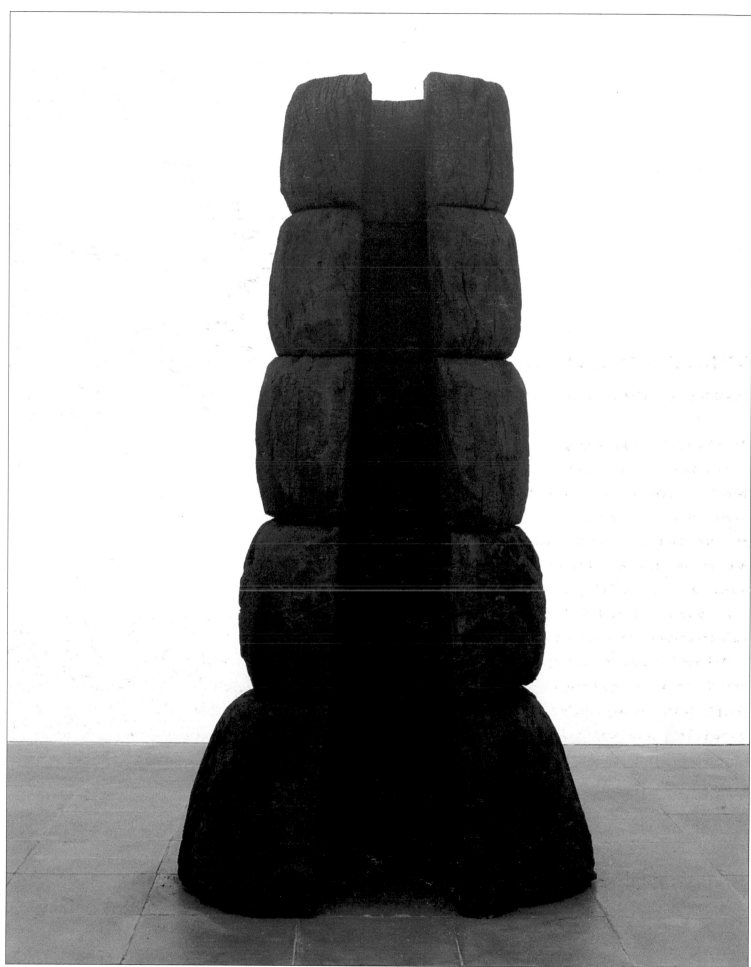

Threshold Column, *1990, charred elm, Llandudno*

WOODEN BOULDER
MAENTWROG, NORTH WALES

1978–

In the summer of 1978 a massive oak, recently felled, became available high above the Ffestiniog Valley. Its owners had feared that it would fall on their cottage. Working the tree where it lay over a two-year period, a dozen or more sculptures were extracted. The first piece evolved into the Wooden Boulder.

The mid-seventies had been a period of working with the thin ends of trees – branches and twigs – making linear sculptures, and using hazel to plait into 'ropes' and structures. Feeling the need to return to solid volume I went back to the elemental rough carved balls made in 1971. I carved a very large one, 1 metre in diameter, 400 kilograms in weight, with the intention of taking it inside to dry out and crack. Following the cuts left from the tree's felling there came a point where the half-carved sphere had to be cut loose from the trunk. I intended to roll over it and continue carving the underneath, but being on a slope the rolling was difficult and dangerous. The physicality and implied movement of a sphere became an active reality.

The idea came to make an event – to document an action – with this 400-kilogram beast, and, if eventually exhibited, to show a photograph together with the object to illustrate its origin.

Rolling it into a nearby stream, down a steep slide of water and into a pool would give an image of a big splash; the sphere could then be hauled out and rolled down the track to the road to be transported up to the studio. It got stuck half-way down the water slide. Pondering what at first seemed to be a problem, it became clear that this rough oak sphere should remain in the stream. It became a sculpture of a rock: a Wooden Boulder with continual potential. Since 1978 it has moved downstream eight times.

Wooden Boulder, *1982, oak, Maentwrog*

OVERLEAF: Progress of the Wooden Boulder, *from an original drawing, 1996, charcoal on paper, 50.5 × 84.5 cm*

Wooden Boulder
Maentwrog N.Wales.

Into second pool
August '80
where it stays for eight years

Rolled further down stream
June '88

Storm moves boulder
150 metres December '90

Rests in shallows

moves in storm
December '74

lodged in waterfall
November '78

cut from an
oak trunk October '78

winched to shallows
May '79

River Dwyryd

wedged under a bridge

moved beyond
bridge May '95

David Nash '96

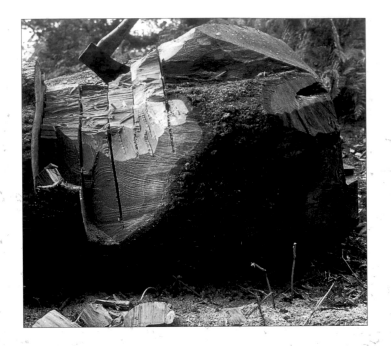
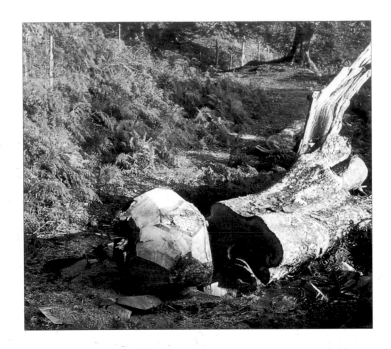
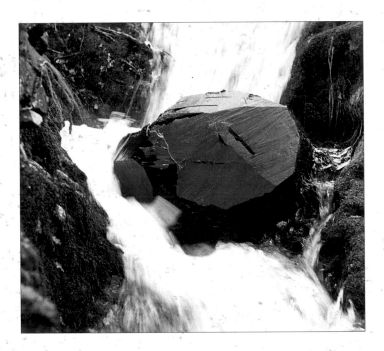
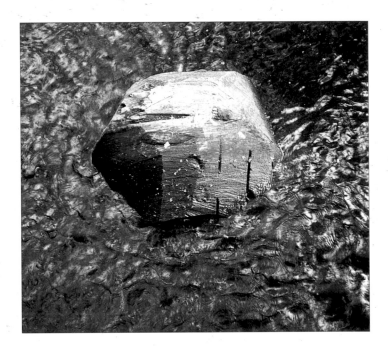

The making and progress of Wooden Boulder, *from November 1978 to May 1979, Maentwrog*

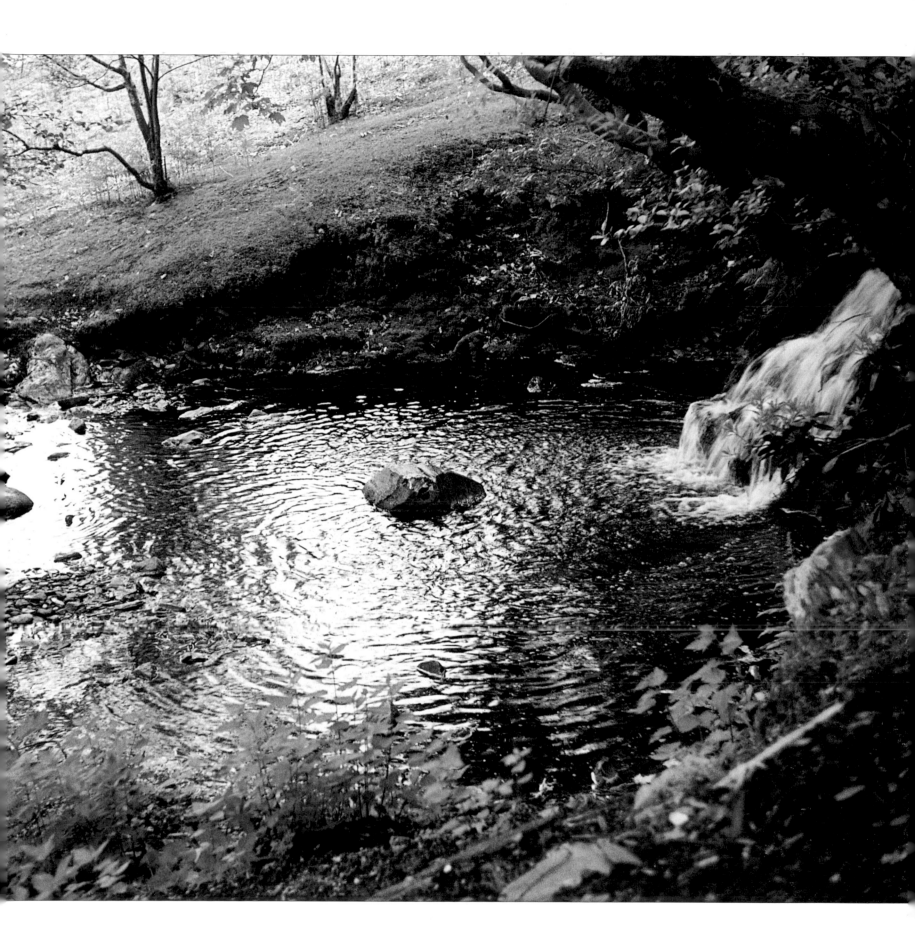

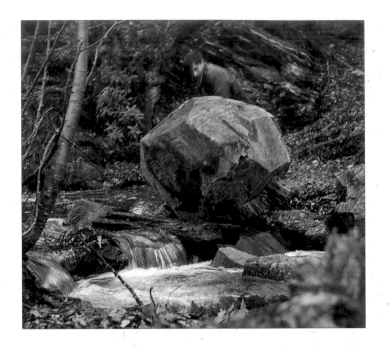 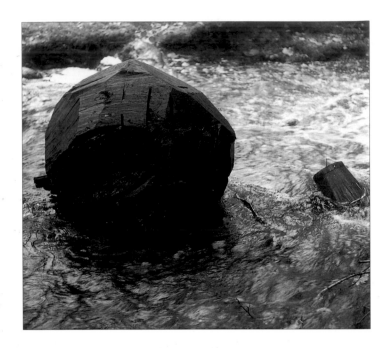

 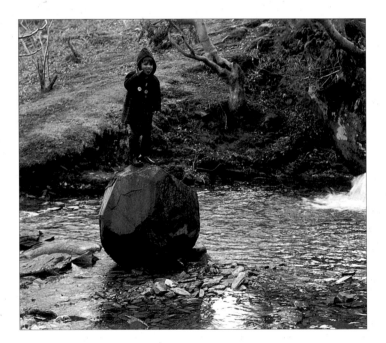

The progress of Wooden Boulder, *from November 1979 to August 1980, Maentwrog*

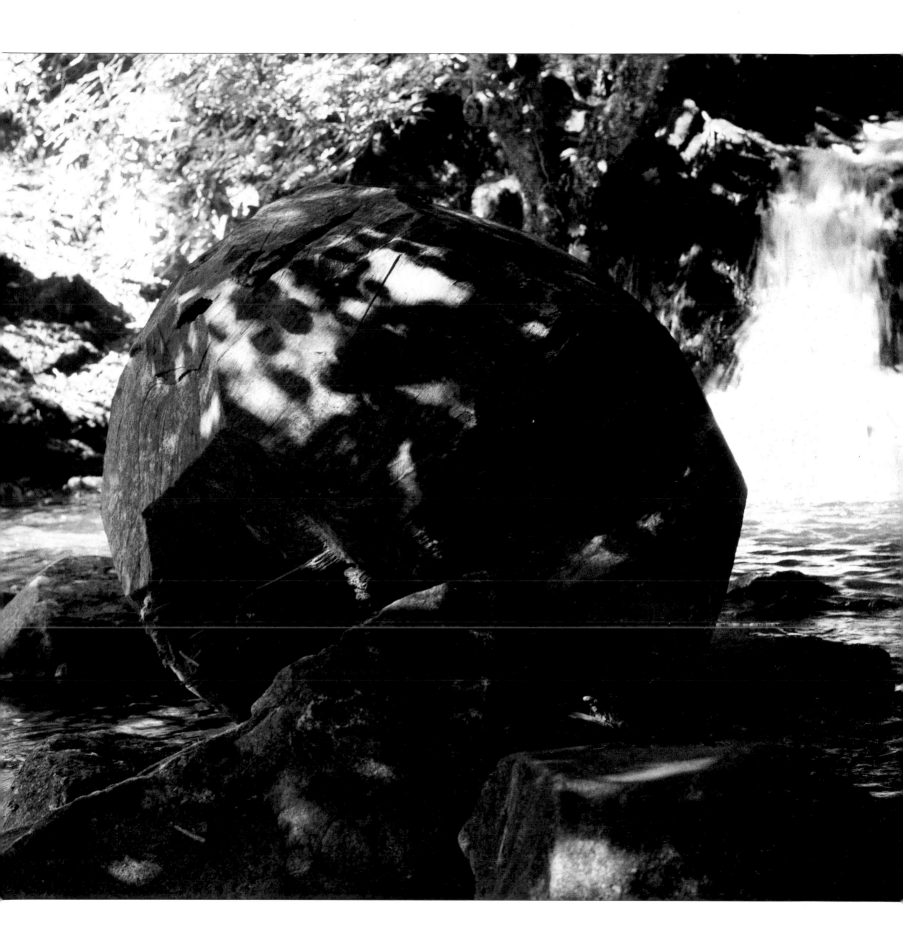

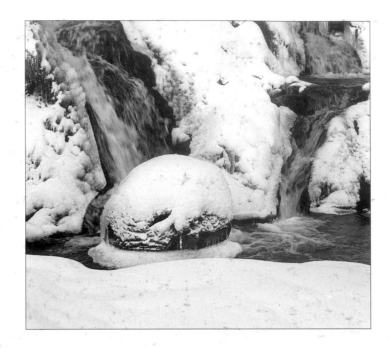
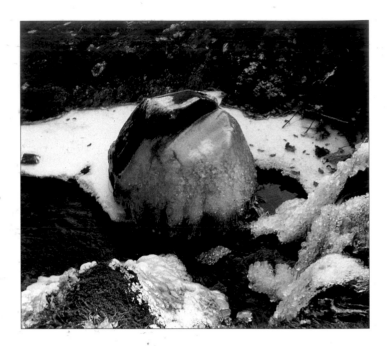
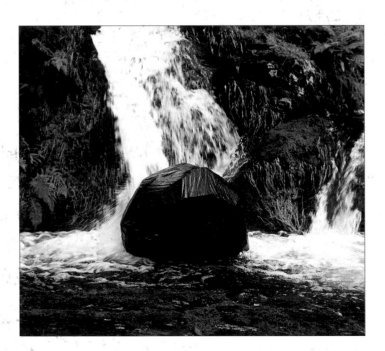
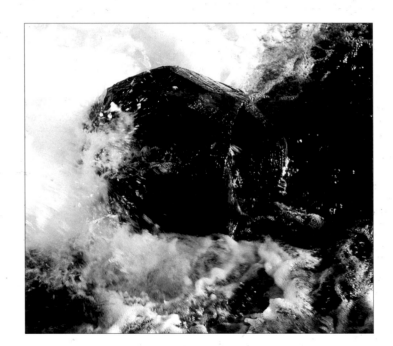

The progress of Wooden Boulder, *from December 1980 to March 1988, Maentwrog*

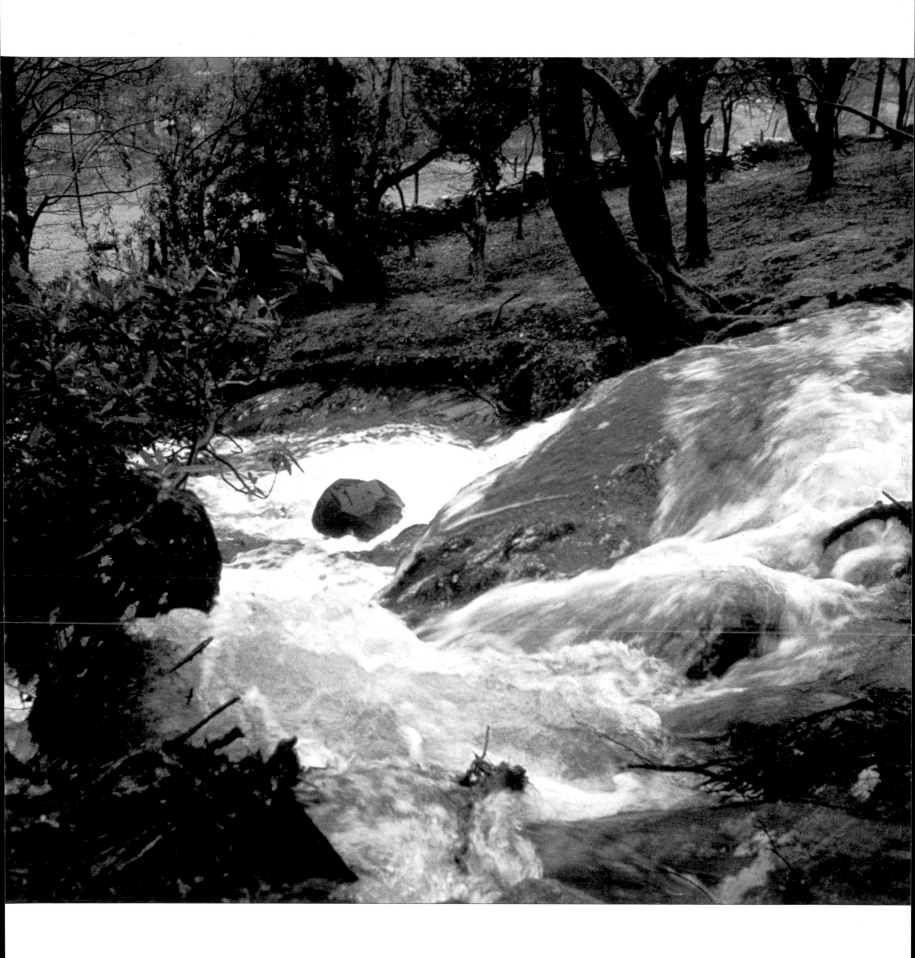

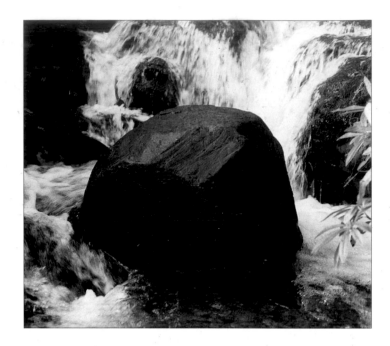
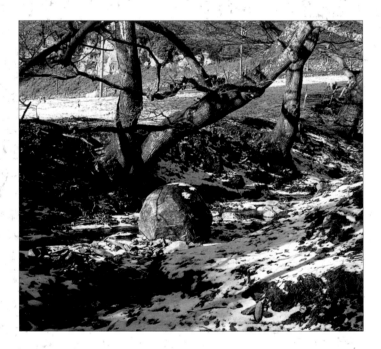
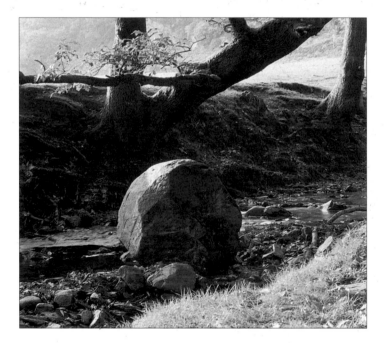

The progress of Wooden Boulder, *from March 1988 to August 1994, Maentwrog*

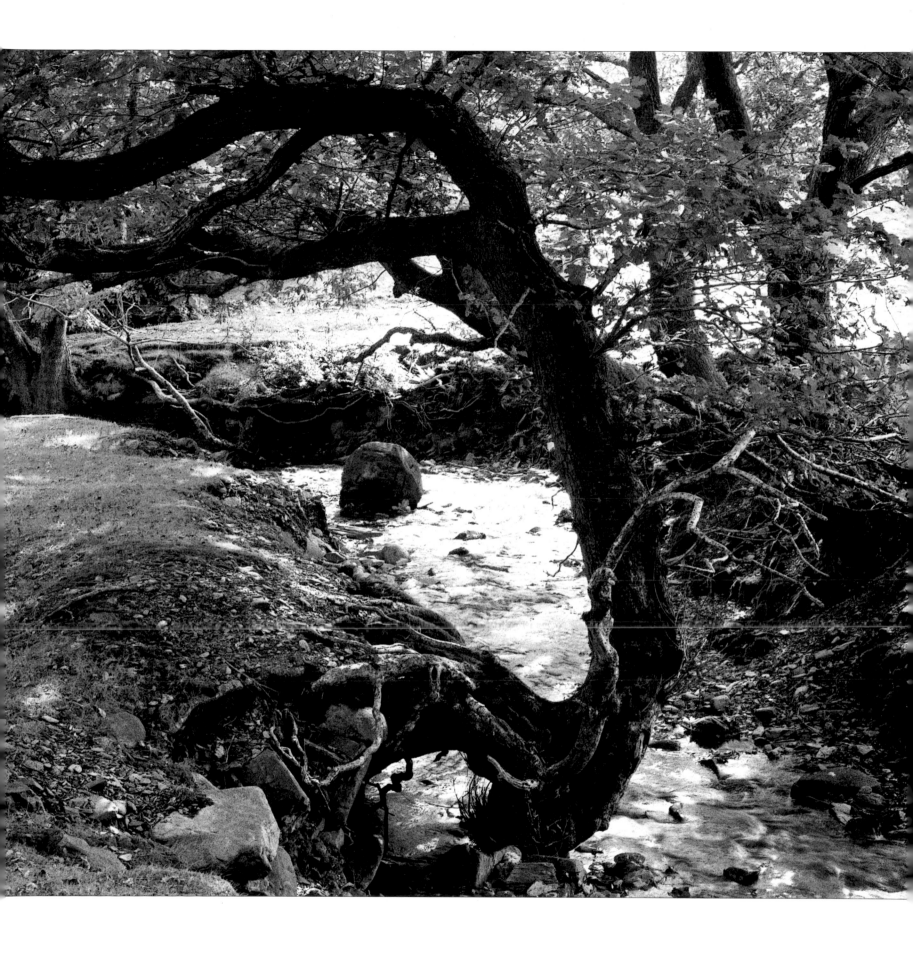

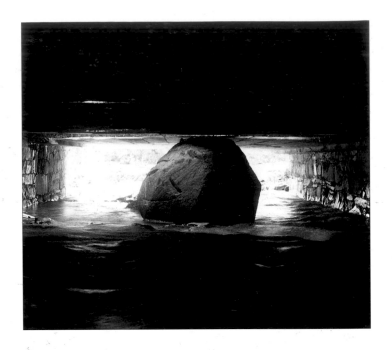
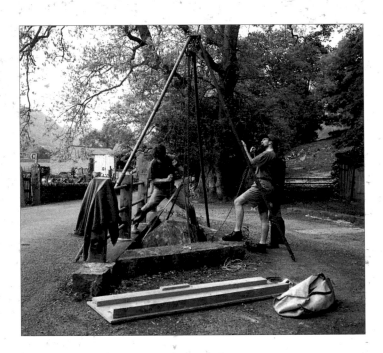
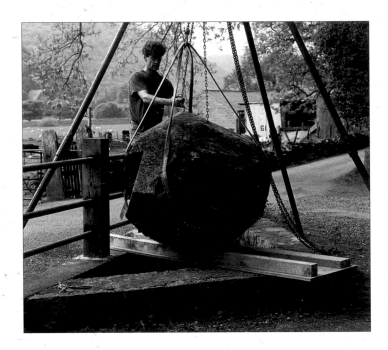

The progress of Wooden Boulder, from December 1994 to May 1995, Maentwrog

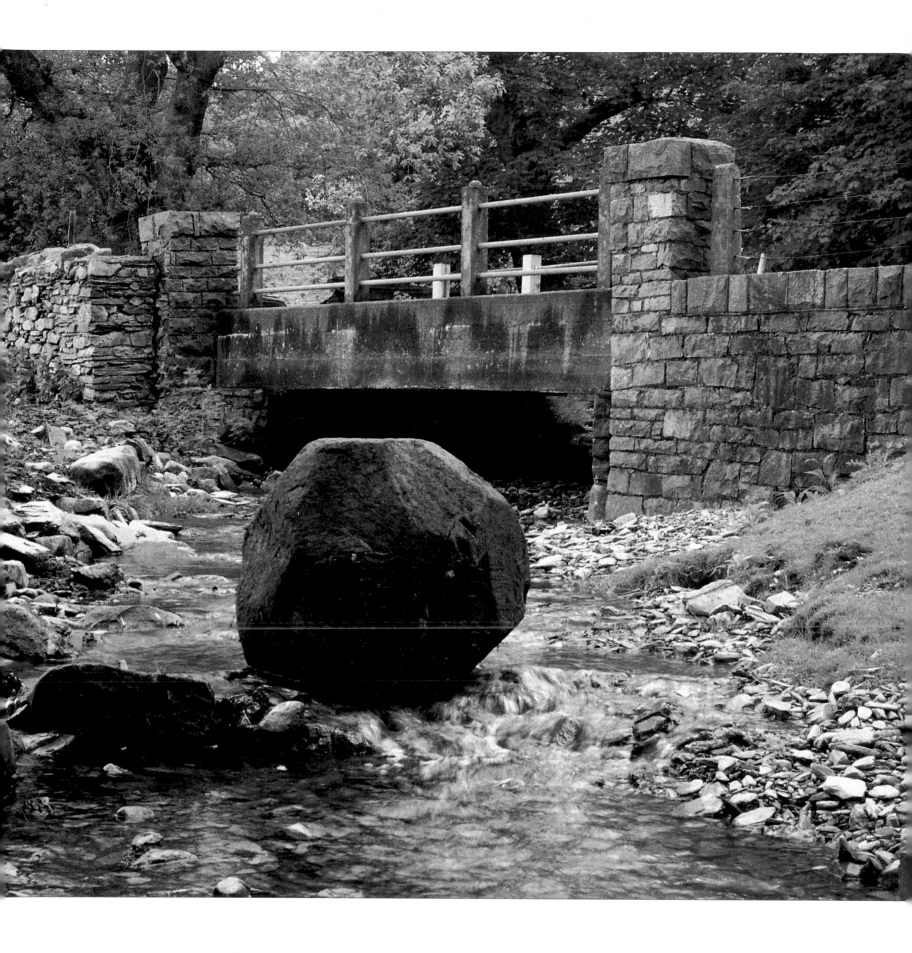

ASH DOME
CAE'N-Y-COED, NORTH WALES

PLANTED MARCH 1977

A ring of twenty-two ash trees tended over a thirty year period to form a domed space.

The mid-seventies was a period of economic and political gloom: the cold war was very tense, and there was a general depression in the air, a feeling that we would not see the end of the twentieth century. The Ash Dome was conceived as an act of faith in the future: a sculpture for the twenty-first century. At this time I had been struggling with how to make a large-scale outdoor sculpture which was genuinely of its location and actively engaged with the elements; so much outdoor sculpture seemed unsatisfactory in its attempt to resist the vagaries of nature. A Buddhist tenet, 'We get along better if we collaborate with nature instead of trying to dominate it', seemed the way forward. Hedges are a good example.

Through a study of hedges, ash showed itself to be the most resilient to shaping and able to lean a long way from its roots. Twenty-two ash saplings were planted in a ring 9 metres in diameter on a level area of hillside in the Ffestiniog Valley with the intention of growing a domed space. I am guiding the trees in the manner of the ancient Chinese potters who kept their minds on the invisible volume of space inside their pot and worked the clay up around the shape of that space. Another inspiration was hearing that the British Navy had planted oaks in 1800 to build a fleet in the late twentieth century. These woods are now mature – I love that long-term thinking.

Sheep ate the first ring of trees so I planted another, this time inside a fence. Rabbits tried to eat the bark of these so they had to be protected. Birch trees were also planted to provide a wind break and act as competition to encourage growth in the ash trees. Using hedgerow methods, mulching, grafting and pruning, the 'ongoing sculpture' has changed over eighteen years from twenty-two thin 1-metre wands in an open space to a dense woodland cover where the dome form is discerned by the thickening trunks. The experience has been one of direct contact with the vitality of these trees, their metamorphosis year to year, and their 'breathing' through the seasons. The 'idea' demands my presence to see it through.

Ash Dome, 1976, charcoal on paper, 50 × 50 cm

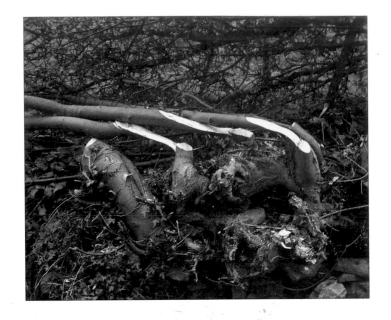

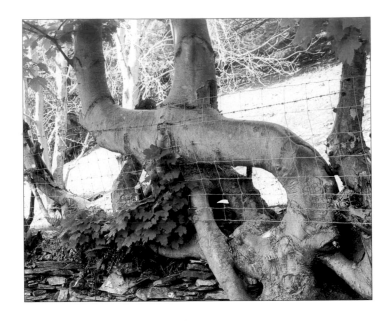

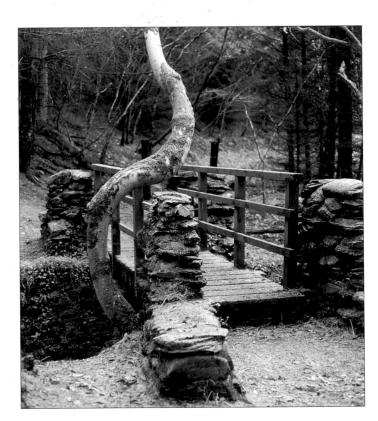

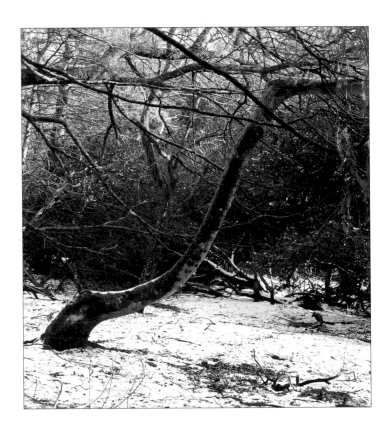

Research for Ash Dome, observing trees

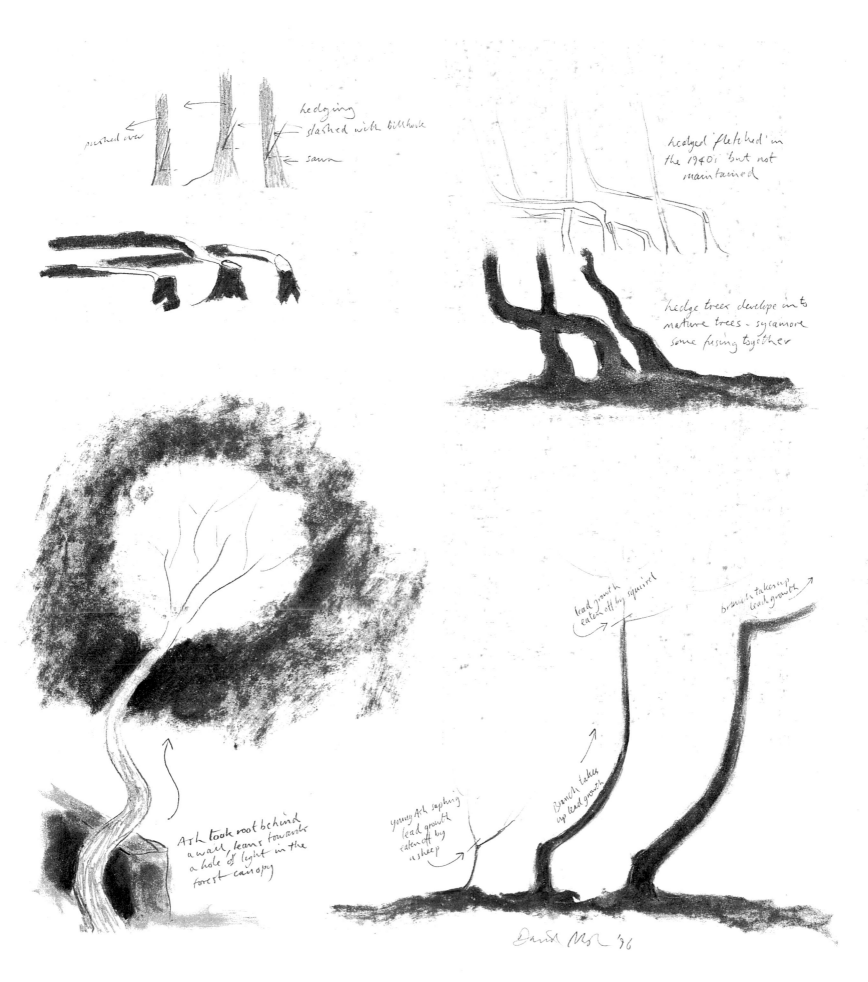

pushed over

hedging
slashed with billhook

sawn

hedged 'fletched' in
the 1940's 'but not
maintained

hedge trees develope into
mature trees - sycamore
some fusing together

Ash took root behind
a wall leans towards
a hole of light in the
forest canopy

lead growth
eaten off by squirrel

branch takes up
lead growth

Branch takes
up lead growth

young Ash sapling
lead growth
eaten off by
a sheep

David Nash '96

Observing Trees, 1995, charcoal and graphite on paper, 54.2 x 50.2 cm

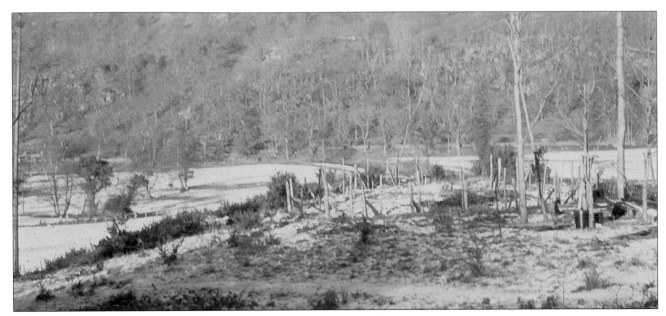

Ash Dome, *ring of twenty-two ash saplings planted in March 1977, Cae'n-y-Coed*

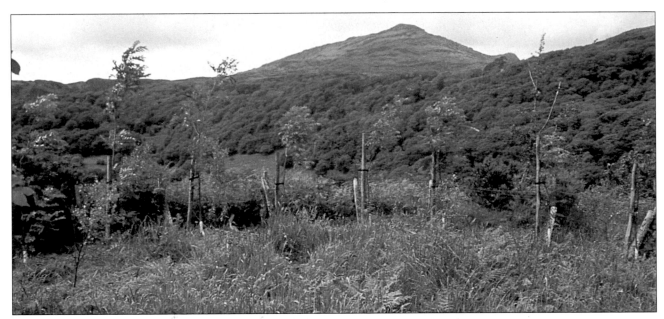

Ash Dome, *growing trees, 1980, Cae'n-y-Coed*

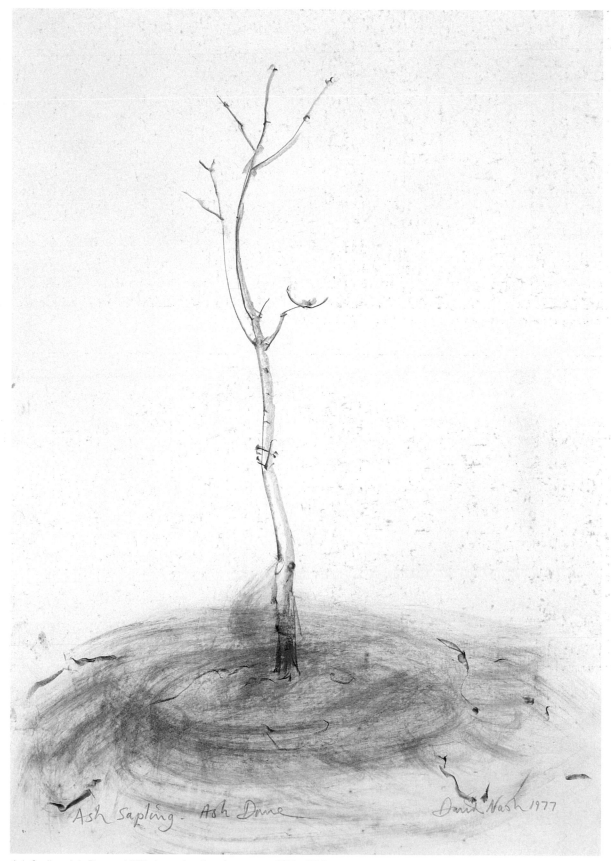

Ash Sapling, Ash Dome, *1977, charcoal and earth on paper, 70.5 × 50.5 cm*

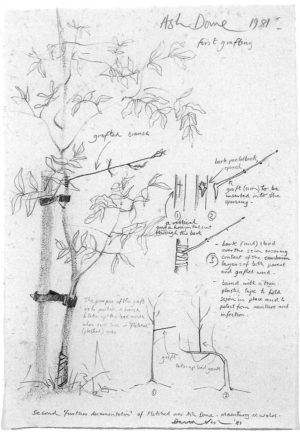

Ash Dome, *grafting, March 1980, Cae'n-y-Coed*

Ash Dome, First Grafting, *1981, pencil on paper, 58 × 38 cm*

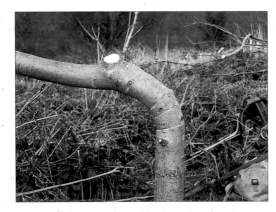

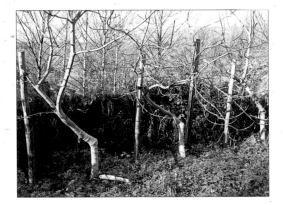

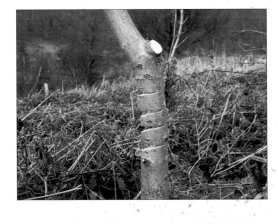

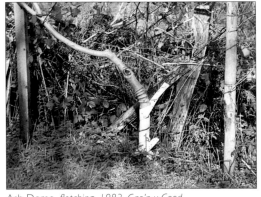

Ash Dome, *fletching, 1983, Cae'n-y-Coed*

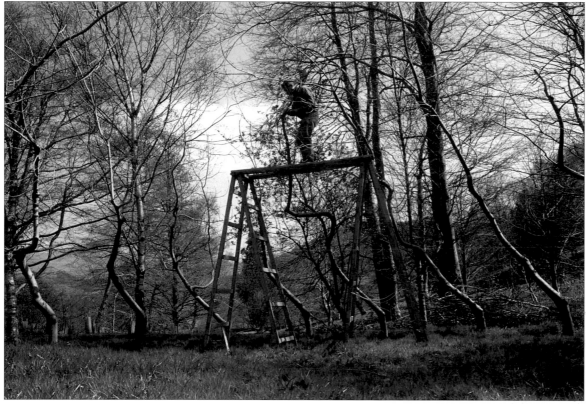

Ash Dome, *spring 1995, Cae'n-y-Coed*

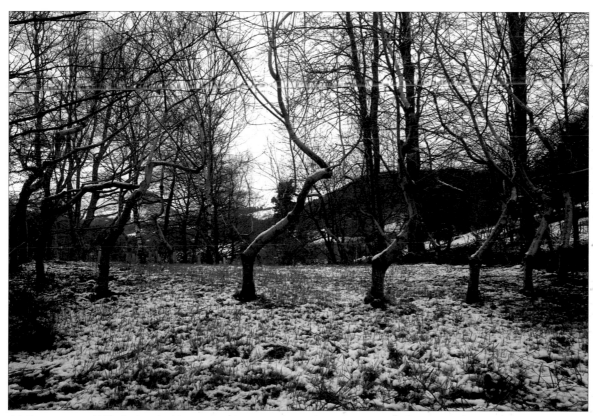

Ash Dome, *winter 1995, Cae'n-y-Coed*

Ash Dome, *1995, pastel on paper, details from 2 drawings each measuring 29.5 × 42 cm*

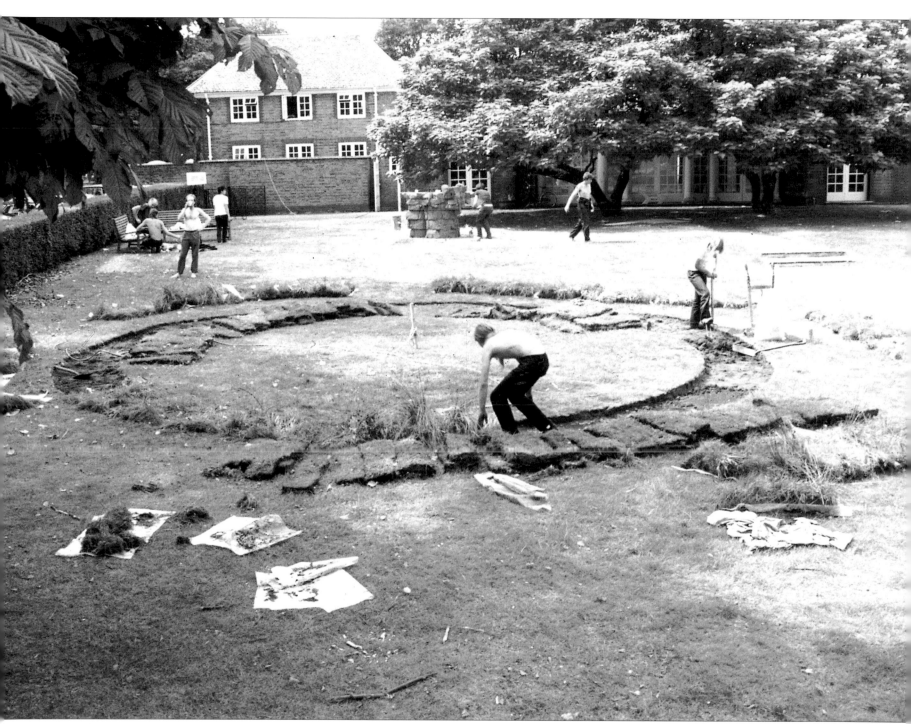

Sod Swap, 1983, Kensington Gardens

London

Daisy, Rye Grass, Common Mouse-ear
chickweed.

SOD SWAP

an exchange of turfs and sods
between N. Wales and London
1983

North Wales —

Thin-runner Willow Herb. Moss, Common Mouse-ear Chickweed. Bluebell,
Thyme-leaved Speedwell, Bracken, Common St. John's Wort. Bramble,
Procumbent Cinquefoil. Ragwort. Common HempNettle Soft Rush,
Scented Vernal Grass, Hogweed, Creeping Soft grass, Cocksfoot. Common Catsear,
Hardheads, Lesser Stitchwort, White Clover, Ribwort Plantain, Common Bent,
Common Sorrel. Birdsfoot Trefoil. Sheeps Sorrel, Red Campion, Yorkshire Fog.

David Nash '92

Sod Swap, 1993, pastel and charcoal on paper, 100 × 70 cm

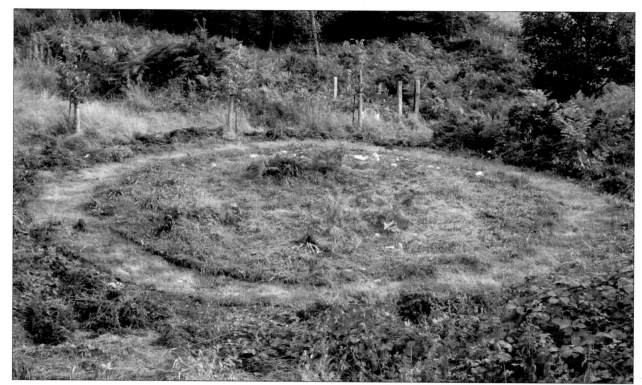

London sods at Cae'n-y-Coed, summer 1983

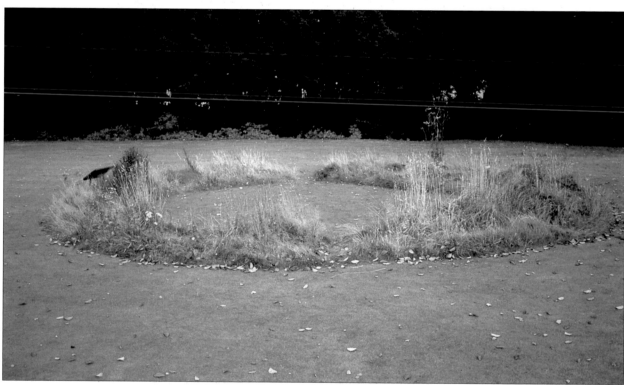

Welsh sods in Kensington Gardens, winter 1990

STANDING FRAME
MINNEAPOLIS, NORTH AMERICA

1987 AND 1994

Thirty spokes share one hub.

Adapt the nothing therein to the purposes in hand, and

you will have the use of the cart. Knead clay

in order to make a vessel. Adapt the nothing therein to the

purpose in hand, and you will have the use of the vessel.

Cut out doors and windows in order to make a room.

Adapt the nothing therein to the purpose in hand,

and you will have use of the room.

Thus what we gain is something, yet it is by its virtue

of Nothing that this can be put to use.

(Lao Tsu, *Tao Te Ching*, fifth century BC)

The frame (Nature Frame) made in Japan in 1984 was installed on a pavement in Tokyo outside the Sogetsu Kaikan, an Ikebana school, as part of an exhibition. Martin Freedman, the director of the Walker Arts Center in Minneapolis, saw it there and imagined such a sculpture together with a Sol le Witt sculpture at the Walker – a 'shoot out' as he later described it. The le Witt piece is an arrangement of cube frames made of steel painted pure white. Martin Freedman recognised the same geometric purity being sought in Nature Frame as in the le Witt, but from opposite directions.

In autumn 1987 a new version Standing Frame was commissioned for the Walker. An artist living an hour out of Minneapolis had suitable oak on his land and the facilities for construction. To avoid having to use a tractor to extract the wood from the forest we worked with a horse, Bob, to haul the timber – a practice used all over the world for centuries but now rare in the technically advanced cultures of the West, and a first for me. The presence of the horse brought a different quality to the work site and to the work itself: there was more sense of coaxing the form into existence than demanding it.

In respect to Sol le Witt I made the interior frame dimensions and overall height exactly the same as his frame sculpture. The Standing Frame was later moved to the Walker's new sculpture garden. As with all wood outside it gradually turned from its original amber colour to a silver grey and became like a shadow in its new location. To restore its presence I returned to Minneapolis in 1994 and charred it black.

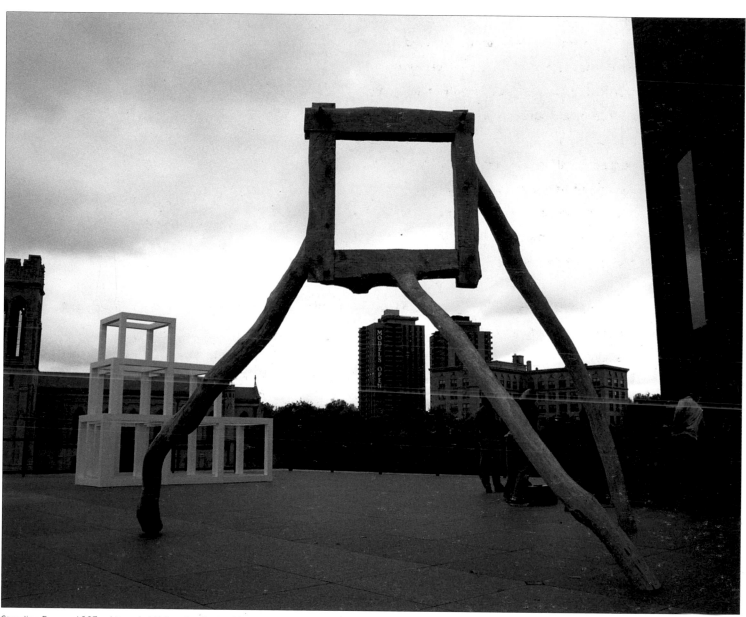

Standing Frame, 1987, white oak, Walker Art Center, Minneapolis

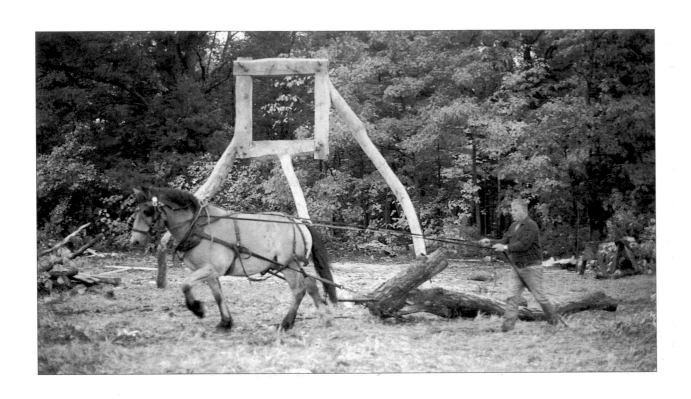

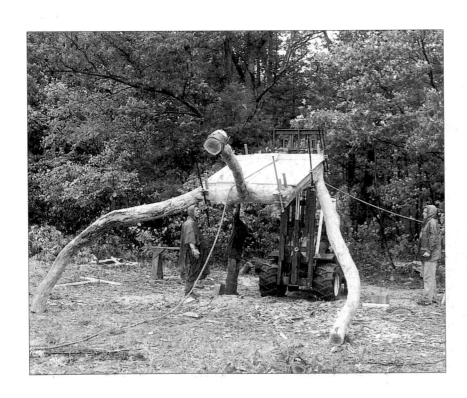

Manoeuvring and installing Standing Frame, Minneapolis, 1987

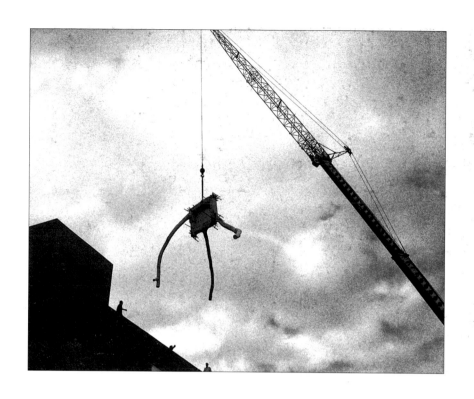

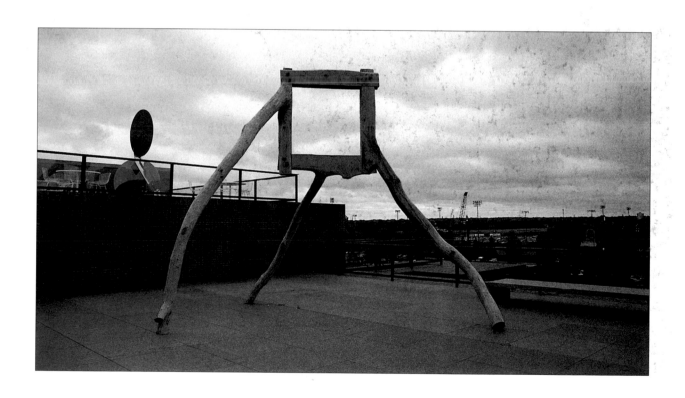

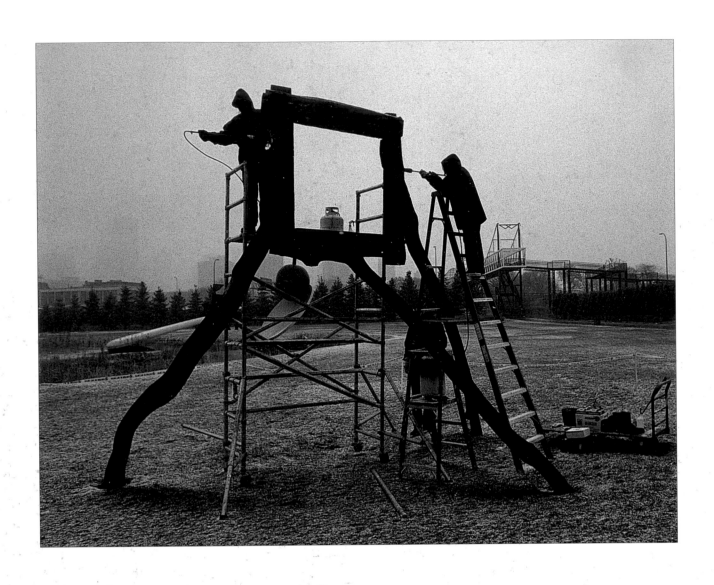

Charring Standing Frame, April 1994, Walker Arts Center, Minneapolis

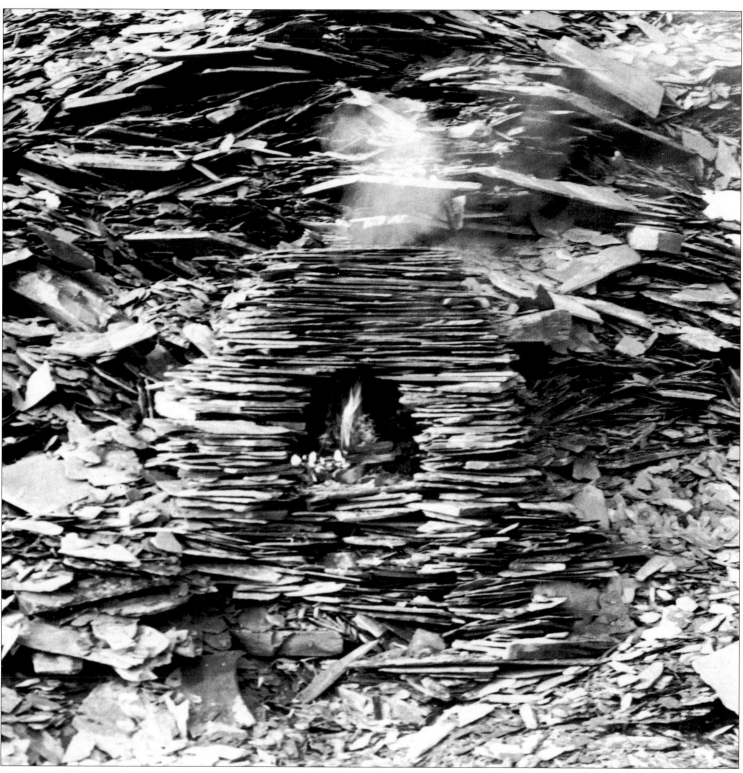

Slate Stove, 1988, Blaenau Ffestiniog, North Wales

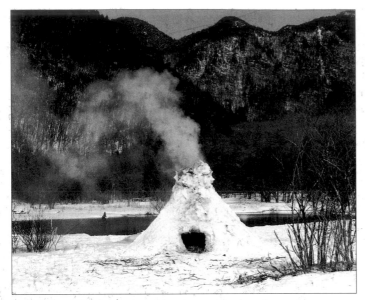

Snow Stove, *1982, Kotoku, Japan*

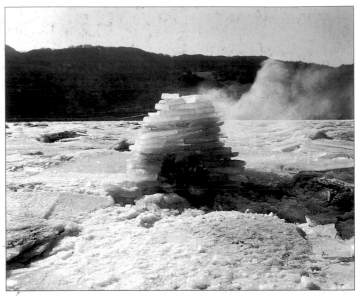

Ice Stove, *1987, Ffestiniog Valley, North Wales*

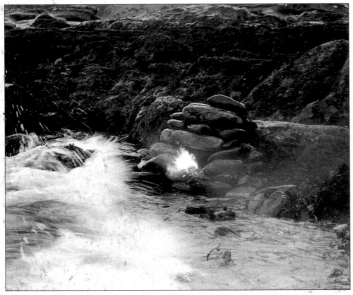

Sea Stove, *1981, Isle of Bute, Scotland*

Clay Cliff Stove, *1982, Aberdaron, North Wales*

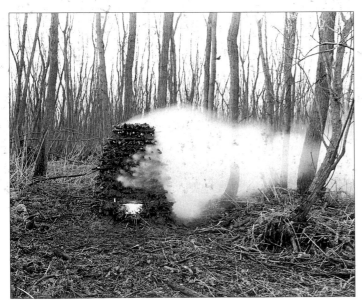

Sticks and Clay Stove, *1981, Biesbos, The Netherlands*

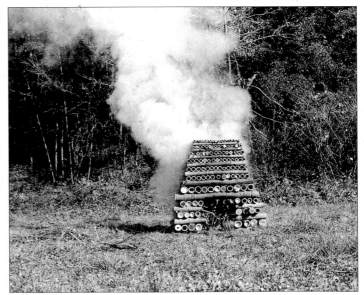

Bamboo Stove, *1984, Yumoto, Japan*

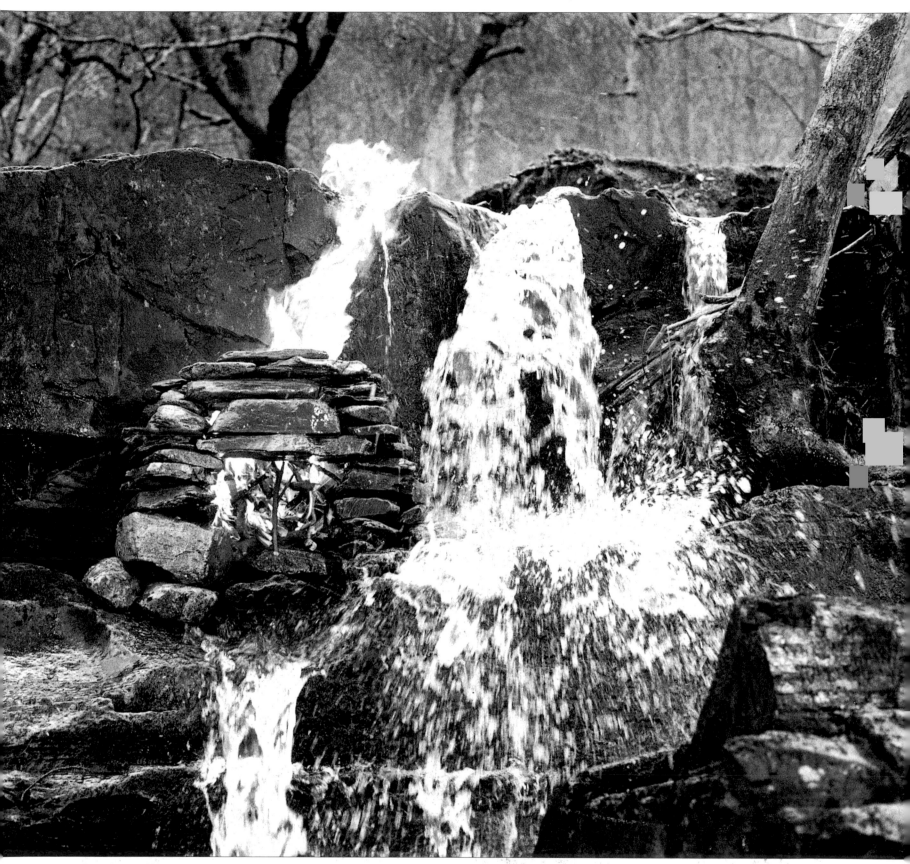

River Stove, 1988, Maentwrog, North Wales

LADDERS

1983–

A linear, self-supporting structure needs at least three legs in order to stand. The tripods of the mid-seventies explored the possibilities of this physical fact by following the materials' inherent qualities: loosened hazel fibres led to plaiting, flexible ash to weaving, split chestnut to wedging and pegging. The image focus became the 'pelvic' meeting between the 'legs' and the upper 'body'. The process revealed the image.

Splitting wood and pushing apart the two halves creates a space, a doorway, which needs to be pegged horizontally to stand in the image of a ladder.

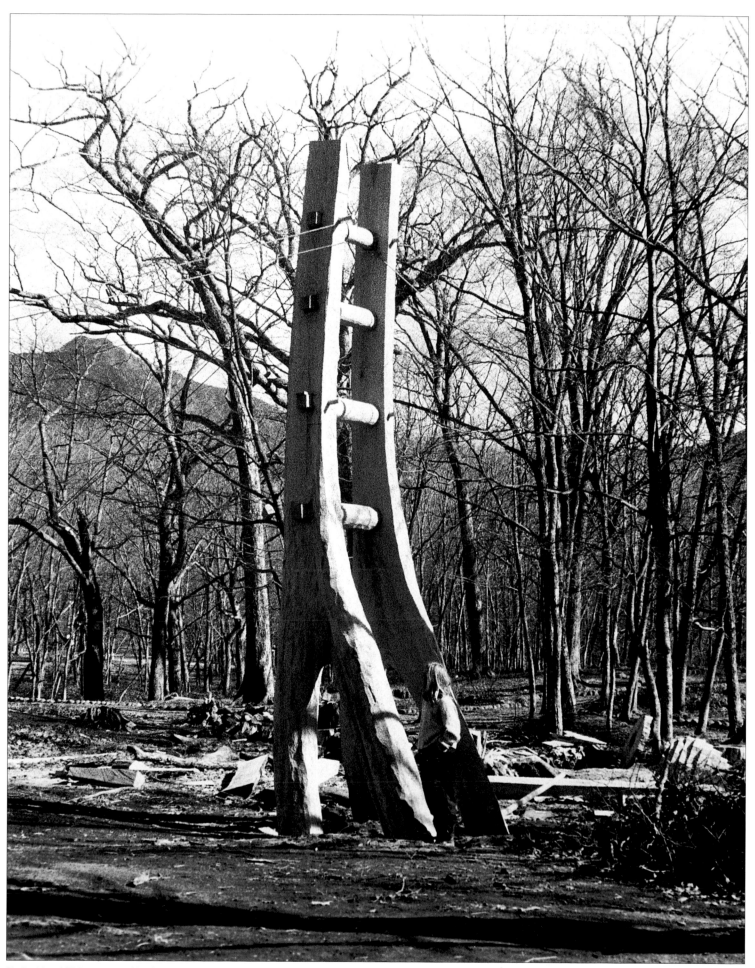

Big Ladder, *1984, mizunara, Kotoku, Japan*

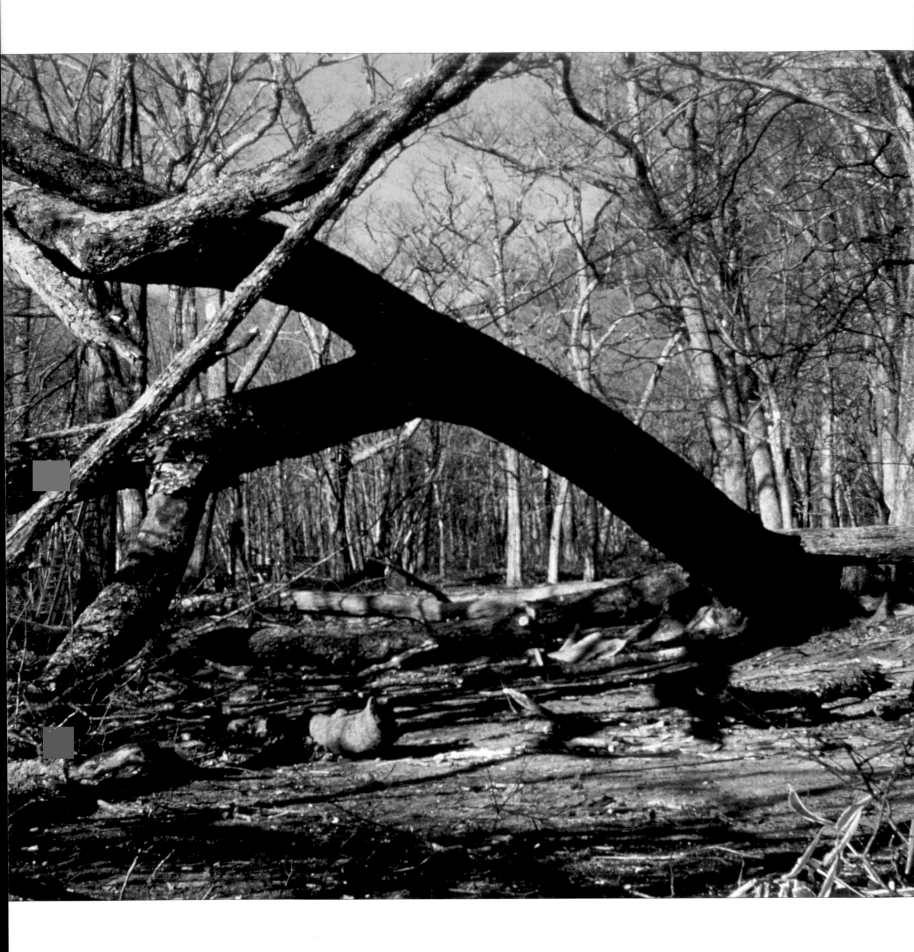

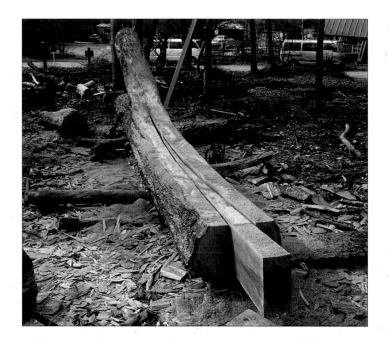
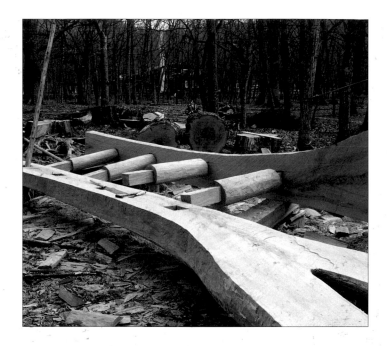
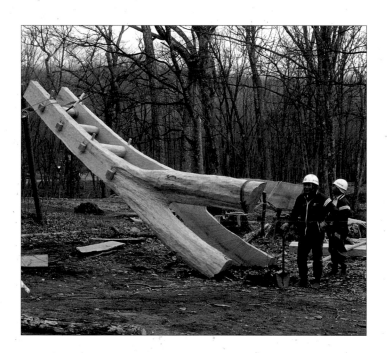
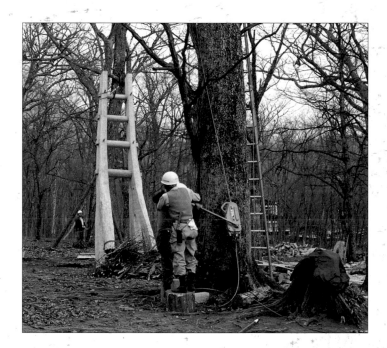

Transforming a mizunara into the Big Ladder, 1984, Kotoku, Japan

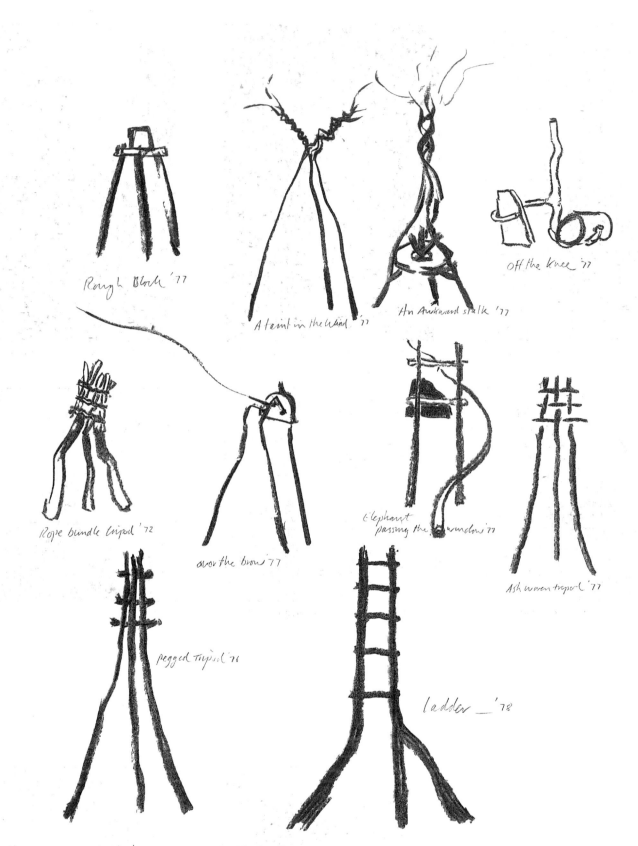

Rough Block '77

A taint in the Wind '77

An Awkward stalk '77

Off the Knee '77

Rope bundle tripod '72

over the brow '77

Elephant passing the window '77

Ash woven tripod '77

pegged tripod '76

Ladder '78

Tripod to Ladder — David Nash '96

Tripod to Ladder, 1996, charcoal and pencil on paper, 44 × 57.5 cm

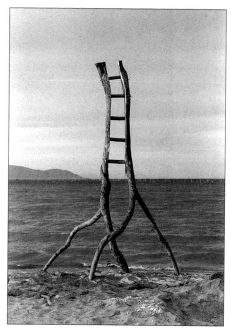

Ladder, 1984, unknown wood, Lake Biwa, Japan

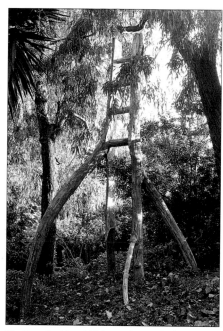

Big Gum Ladder, 1991, eucalyptus, La Jolla, USA

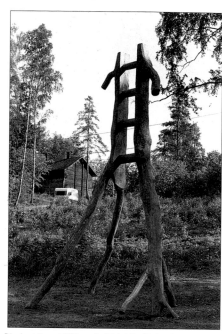

Big Ladder, 1989, oak, Helsinki, Finland

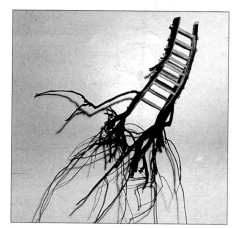

Flying Ladder, 1993, Lime, Bracknell, England

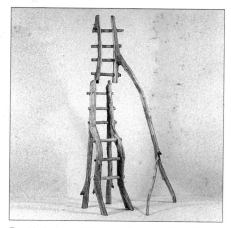

Double Ladder, 1983, oak, Ffestiniog, North Wales

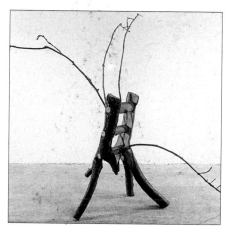

Branch Ladder

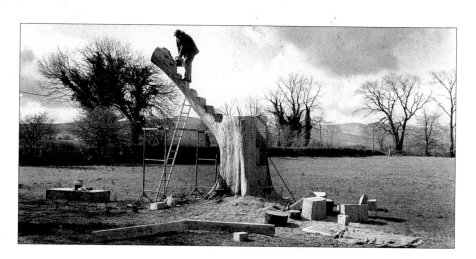

Through the Trunck up the Branch, 1985, elm, Hymenstown, Ireland

SHEEP SPACES

1979–

Animal traces are present across the land on many levels, from the glossy trail of a slug to a fence rail gnawed by a horse. Such traces articulate the form and qualities of a 'place'. Sheep find shelter from wind, rain and sun wherever they can, lying by a rock, wall, bush or hollow. Lanolin from the wool oils the surrounding surfaces. They do not dig or scrape the ground but by their continual presence gradually erode an oval patch – a peaceful space, innocent and holy.

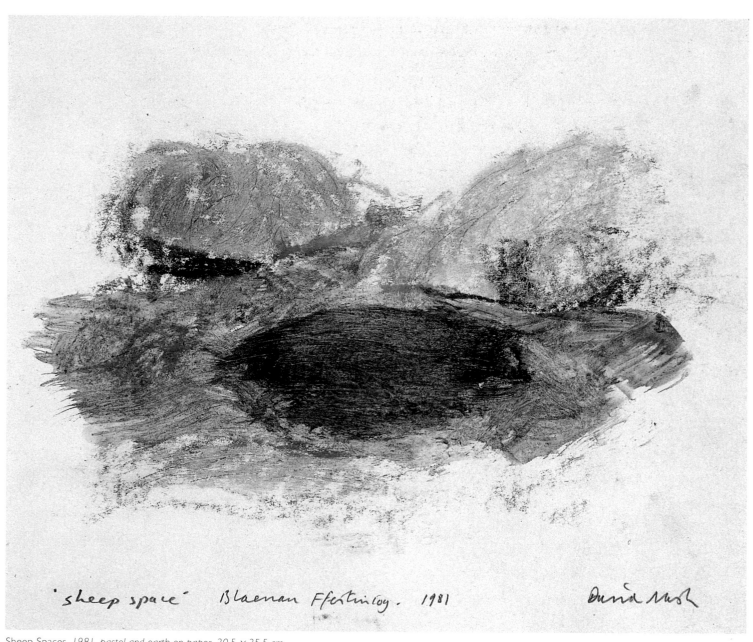

'sheep space' Blaenau Ffestiniog. 1981 David Nash

Sheep Spaces, 1981, pastel and earth on paper, 20.5 × 25.5 cm

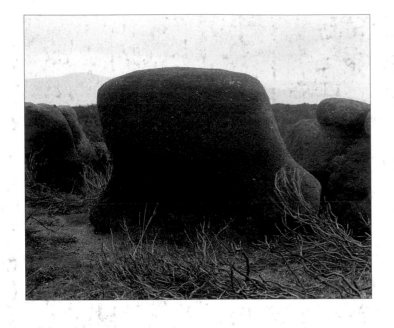

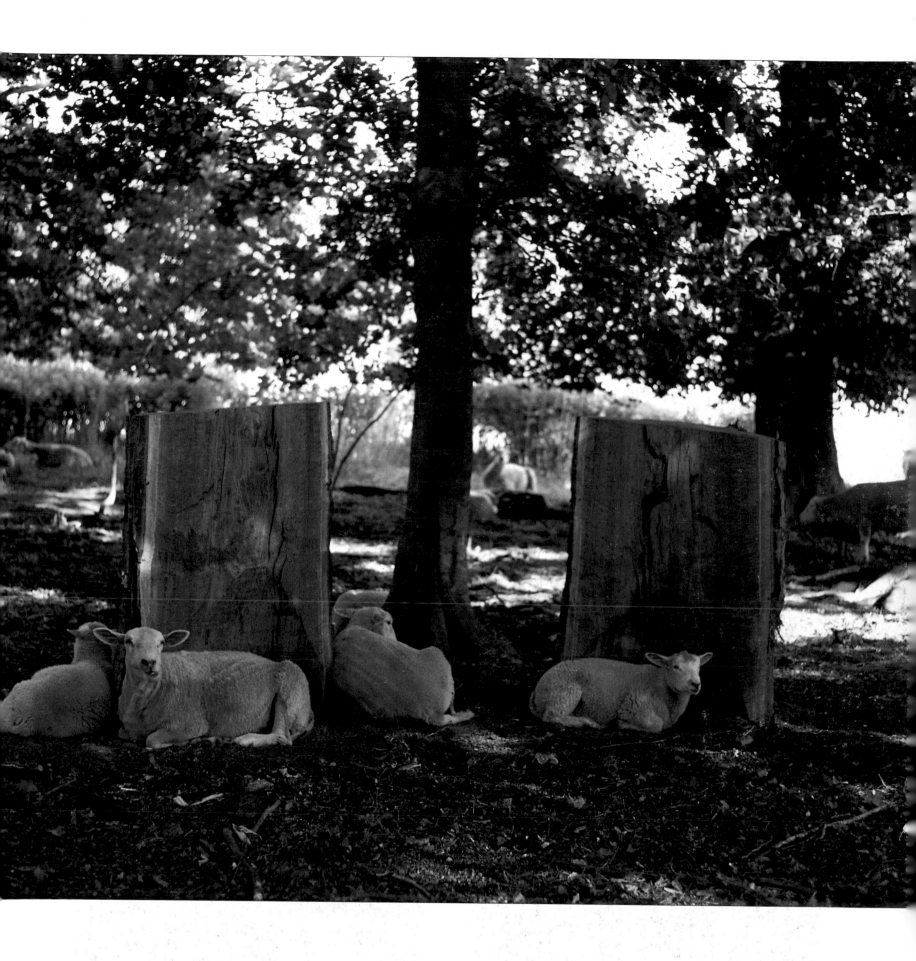

Opposite: Six sheep spaces; Above: Sheep Space, 1993, oak, Tickon, Langeland, Denmark

PYRAMID, SPHERE, CUBE
OTOINEPPU, JAPAN

1993

These forms have an inherent clarity and authority, even when appropriated their integrity is undiminished. Ancient cultures revered geometry as a living force active in all things; for the ancient Greeks Geometria was one of the seven hand-maidens of the Goddess Natura. Our materialism has reduced geometry to a two dimensional static abstraction — a sort of design tool.

Being in awe of these forms, it was difficult to work with them. I made some attempts in the early seventies — a small carving of a pyramid and cube on three shelves, the rough spheres and the table with cubes — but it was not until 1978 that I found a direct way of approaching them when the Wooden Boulder — a rough sphere of oak — ended up in a stream.

My main interest is to bring an activity to geometric form. In the example of the Wooden Boulder the rough marks of carving indicate to an observer that the object is man-made and with this connection it becomes a 'stepping stone' into the activity of its environment — the time reality of the streaming water. The same is true of the cracking boxes — hollow cubes constructed with unseasoned slabs of wood which crack, warp and bend as they dry out. The observer can sense the original geometric form in relation to what it has become and connects with the active reality of the material.

In my travels in different environments I have observed that the four elements are present in different balances and with different qualities. Sometimes a particular element will be dominant; in Japan it is water and in Australia it is fire.

In 1984, when working next to a shallow river in Japan, I was told that in the rainy season it became a raging torrent. In response to this information I carved an oak pyramid, sphere and cube and placed them in the shallow water in anticipation of them being swept away — scattered to other places. In Australia I applied fire to the same forms but in this case retrieved them when I realised drawings could be made of the shapes using their charred surfaces. This in turn led to realising the difference in how we read three-dimensional images. An object exists in space subject to gravity. We read its size in relation to our own body scale, its physical presence being a strong part of the experience. A two-dimensional image is read more directly by the imagination, the physical fact of its size is less pronounced. By putting a physical object on the floor and its image on the wall, the two different experiences of comprehension enhance both object and image, particularly in the case of these basic geometric shapes.

While working on a project in northern Hokkaido one of the dead trees I had been given, a big elm, appeared very rotten, indicating the opportunity for a tall hollow form. When we came to cut it down the rot proved not to be deep, there was much more weight and carvable wood than had been anticipated. The opportunity changed to a large version of Pyramid, Sphere, Cube. The shapes were cut to include the presence of the rotten areas which were carved out and purged by fire. Drawings were made of the charred shapes which penetrated the geometric forms.

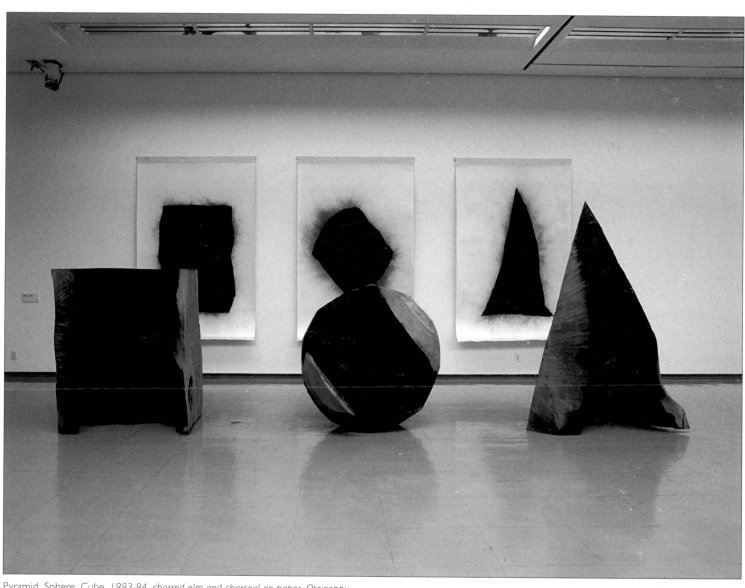

Pyramid, Sphere, Cube, *1993-94, charred elm and charcoal on paper, Otoineppu*

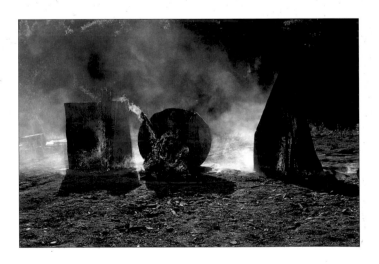

Moving the elm and making Pyramid, Sphere, Cube, *1993, Otoineppu*

Pyramid, Sphere, Cube *in transit*, 1993, Otoineppu

Charred Pyramid, Sphere, Cube in Redwood Stumps, *1992, charcoal and pastel on paper, 120 × 180 cm*

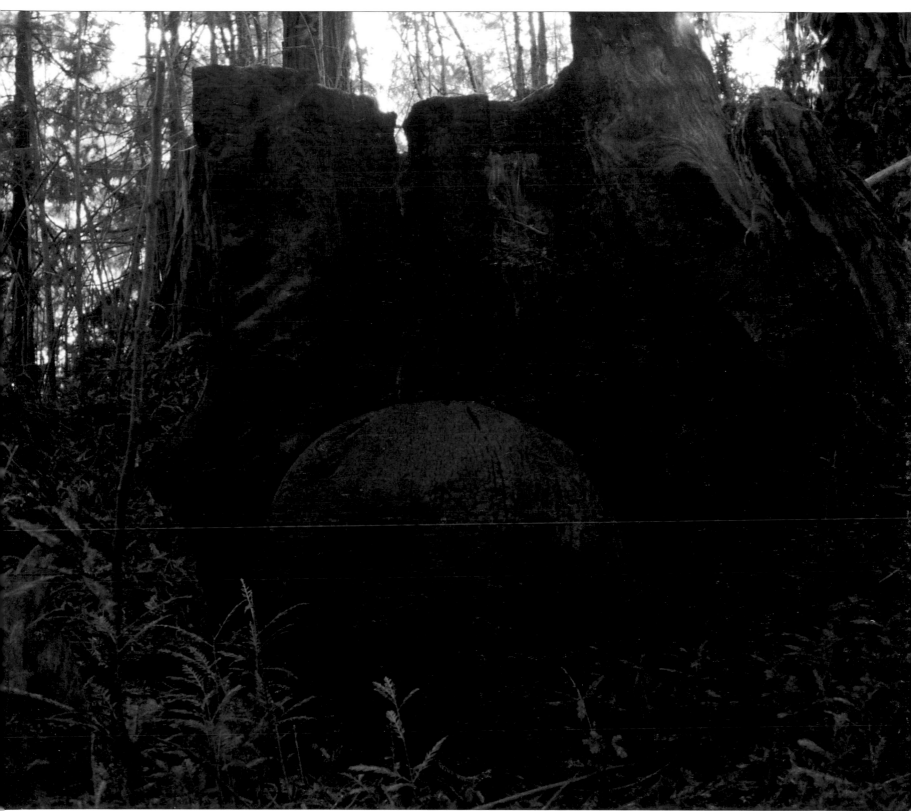

Charred Forms into Charred Stumps, *detail, 1989, redwood, California, USA*

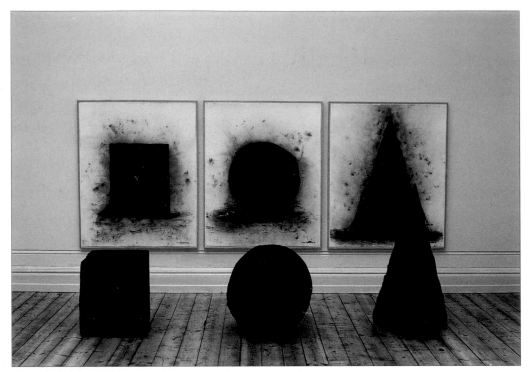

Nature to Nature, *1990, charred elm and charcoal on paper, Capel Rhiw, North Wales*

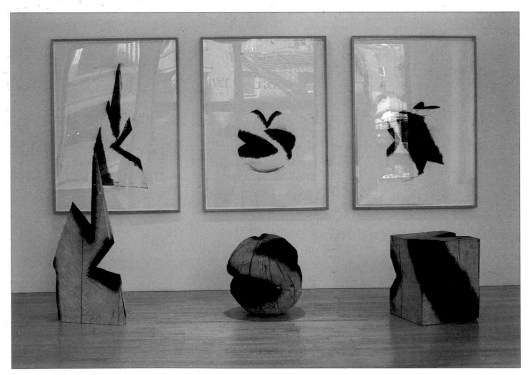

Three Forms, Three Cuts, *1992, partly charred ash and charcoal on paper, Capel Rhiw, North Wales*

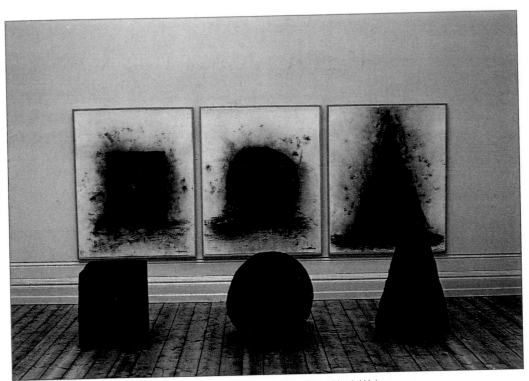

Nature to Nature, 1990, charred elm and charcoal on paper, Capel Rhiw, North Wales

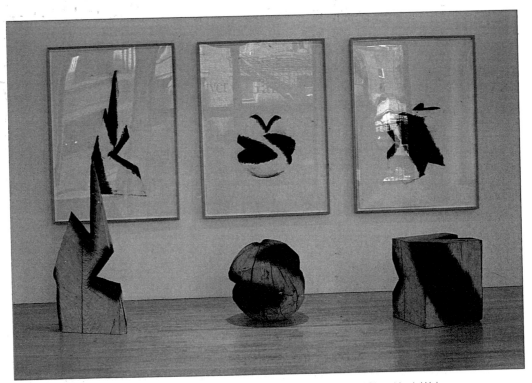

Three Forms, Three Cuts, 1992, partly charred ash and charcoal on paper, Capel Rhiw, North Wales

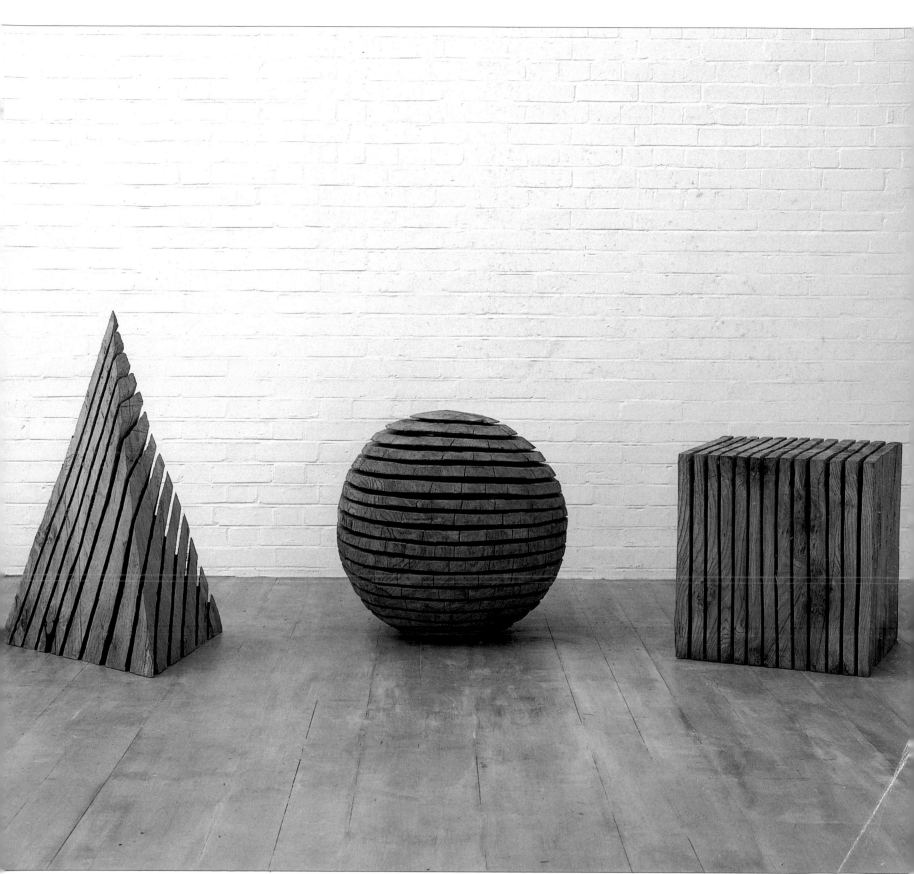

Vertical, Diagonal, Horizontal, *1991, elm, Sheffield, England*

BLUE RING
CAE'N-Y-COED, NORTH WALES

1984–1988

The experience of blue tends to be one of distance, of being drawn out into space. It seems to resist being any fixed shape. In my very early student studies colour form was a particular obsession. Starting with painting I had tried to find appropriate shapes for particular colours, but I became dissatisfied with these flat, two-dimensional images. From here I attempted to make objects whose form was determined by the feel of a colour, focusing particularly on ultramarine blue. I got very lost: the applied colour was always an artificial skin, while what I was after was a volume soaked through with colour.

I abandoned my colour requirement and accepted the natural colour of the supporting material I had been using – wood – which in itself became a teacher and I followed where it led. None the less, the vibrant life of pure colour has continued to be important to me.

Working at 'planted' sculpture drew me more consciously into the cycle of the year; each year there is an abundance of wild bluebells all over the hillside of Cae'n-y-Coed. I realised that here was a possibility to make a work about blue which acknowledged its transient quality and its resistance to being held in a fixed form. The closest acceptable form for blue seemed to be a loose edged circle, a circular indication amidst a sea of blue. I moved thousands of bluebell bulbs into a 30-metre diameter ring on an open slope, and each spring, from a distance, the circle was faintly discernible. After four years the form dispersed into the general covering of blue.

The tiny tear-shaped seed of the blue bell is a deep indigo blue. When in flower the plant droops but lifts itself up as the seed heads form, the fleshy green walls dry out and become a spring loaded cup: the merest touch on the stem triggers the seeds to fly out. As a way of presenting the notion of the Blue Ring I gathered enough seeds to make a loosely scattered circle on a flat surface accompanied on the wall above by a loose blue circle on canvas.

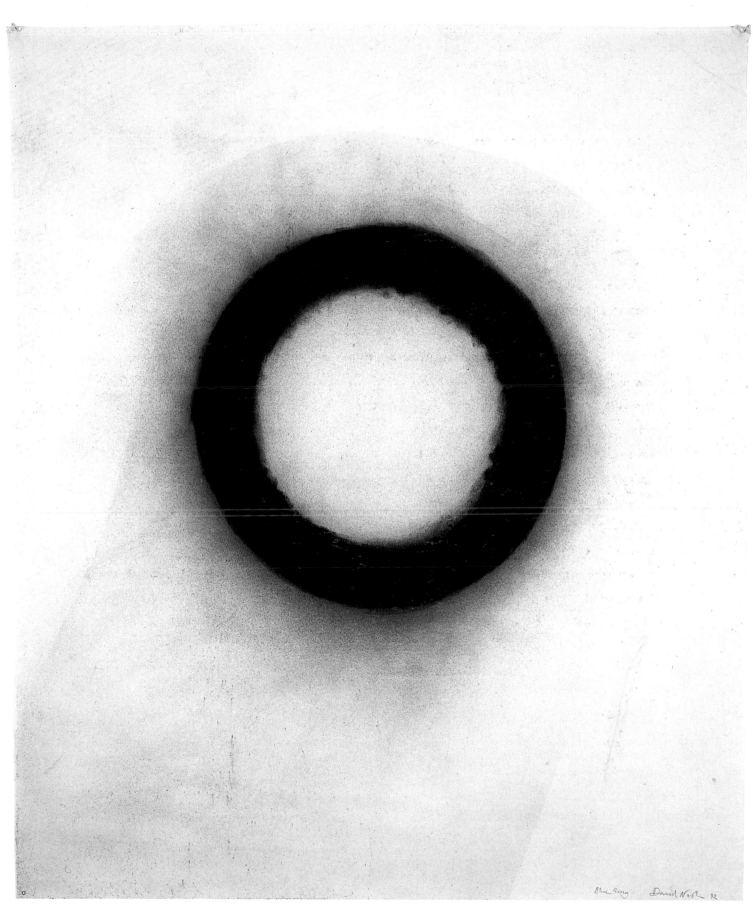

Blue Ring, 1992, pastel on canvas, 280 × 265 cm

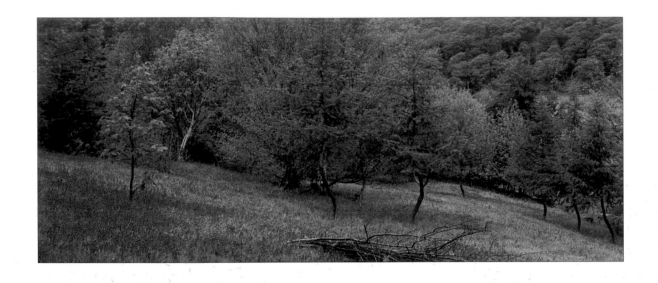

Harvesting bluebell seeds, 1995, Cae'n-y-Coed

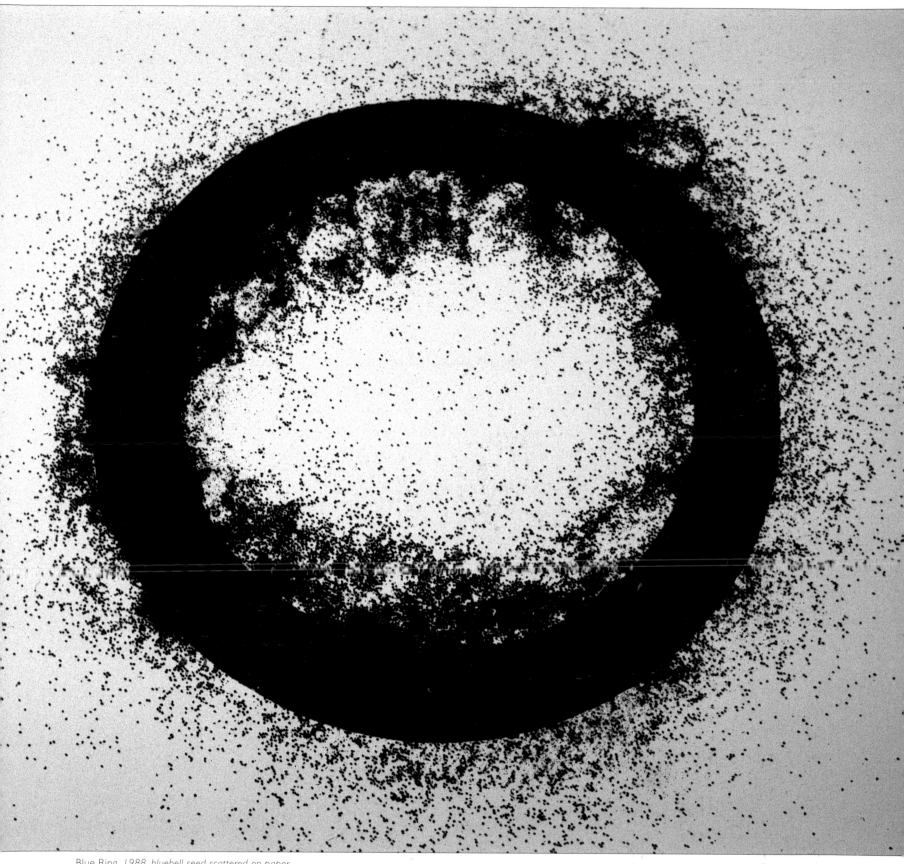

Blue Ring, *1988, bluebell seed scattered on paper*

RED AND BLACK
RADUNIN, POLAND

1991

The origins of Red and Black *lie in a forest in north-eastern Poland where, in 1991, I was working on a group of sculptures for a collaborative show with the painter Leon Tarasewizc. On a preliminary visit to the forest where Leon lives, I had noticed large alders grown commercially which were about to be cut down. When alder is cut the wood is white but within an hour the exposed sap turns it red. I was also offered a damaged oak and some large birch. Intending to make some charred pieces, I realised I had the potent triad of black, red and white – charred oak, alder and birch bark. Looked at separately these colours have many associations: black – dark, densifying contraction, death; white – light, expansion, innocence; red – active, stimulation, life, passion. Red stands between black and white as darkened light and lightened dark.*

These colours occur in many European myths and legends. In an Arthurian story a knight is transfixed by the image of drops of blood in the snow from a wounded goose. In the Holy Grail Parzival is the red knight and his brother's skin is mottled black and white like a magpie; only together can they find the Grail. In another legend Flore's horse is white on one side, red on the other, divided by a strip of black three fingers wide bearing the inscription, 'only he is worthy to ride me who is worthy of a crown'.

When I returned to the Polish forest later that year I found painted on a tree near my work-site a sign of three stripes, white, red and black. No one seemed sure of its origin. I was initially unsure of how to work with these colours and started by simply bringing them together; sections of red alder, charred wood (from the fire used to char other sculptures), and slices of birch bark. The alders were unusually large for their age, growing out of deep crater-like pits – an ideal damp environment for alders. I asked if the pits had been dug especially for growing alders. The reply was that we were working in the area of a long and bloody First World War battle between Russian and German armies, and that the pits were in fact shell craters. The fresh blood red of the alders and the doom of the charred oak took on a deeper significance being made in that place.

Installing the work in the Warsaw Museum, I found that the painted walls provided the element of white, making the birch bark unnecessary.

Red and Black, *1992, charcoal and pastel on paper, 70 × 99 cm*

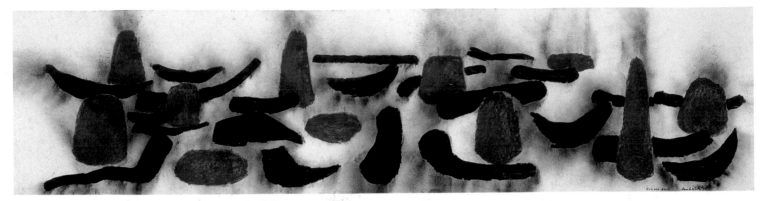

Red and Black, 1992, charcoal and pastel on paper, 60 × 240 cm

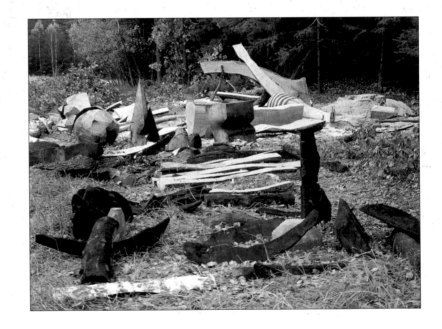

Making Red and Black, 1991, Radunin

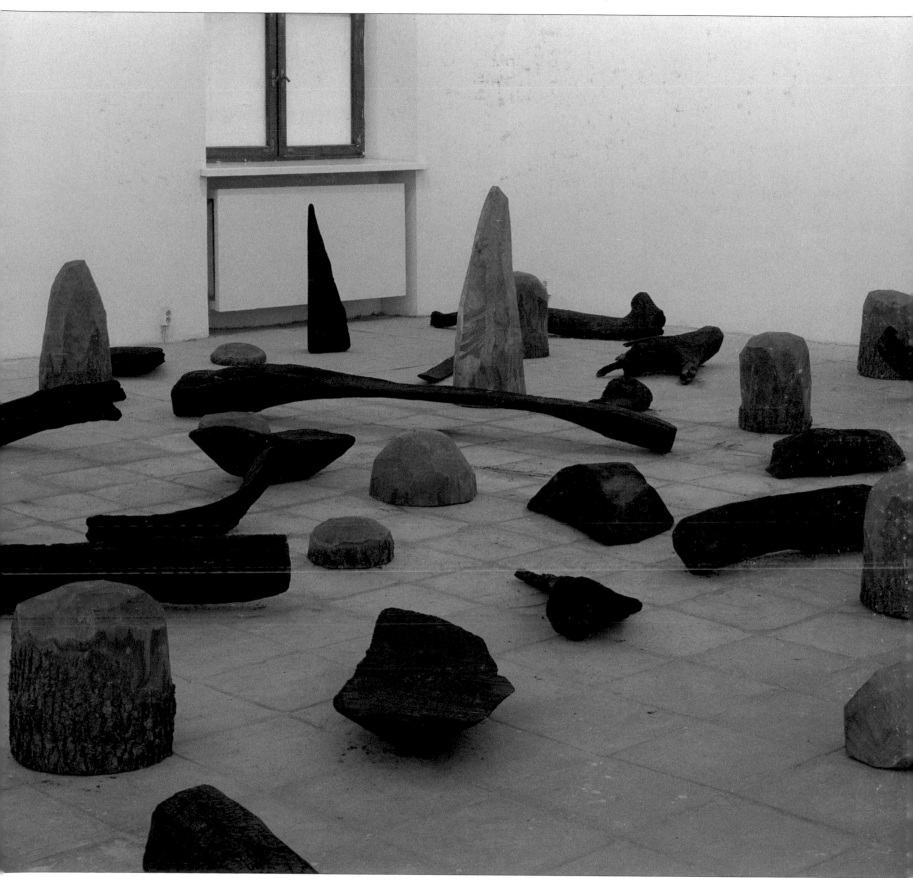

Red and Black, *installation*, 1991, Centre of Contemporary Art, Warsaw

BLACK AND LIGHT GATE
JAPAN

1994

I use a cross in wax crayon or cut the sign with a saw to show which trees I need to work with in a wood yard. It was a natural progression to use the mark in a sculpture, and in Finland I incised an egg form with a repeated cross image.

In the cross two lines meet to create a 'point'; four lines radiate from a centre. Unlike the triangle, circle and square which are universals with a sense of completeness, the cross is an unresolved sign with many uses — from marking a place on a map, denoting error, multiplication and addition, to being a flag emblem or a religious symbol.

Depending on the looseness or formality of the gesture, the size, length of line, and shape of the form to which it is applied, the cross 'mark' activates very different associations. It is a loaded sign.

The Gate was made in Hokkaido as an entrance for a touring exhibition in Japan: a two-tonne oak trunk cut in half to form two pillars, a cross shape cut right through on one pillar and carved deeply into the other. To char the upper two-thirds, snow was packed around the bases, with planks and kindling placed above. The sculptures were set on fire for thirty minutes to create two different experiences of the cross. On the one side one sees through the volume, on the other, into the volume: black and light.

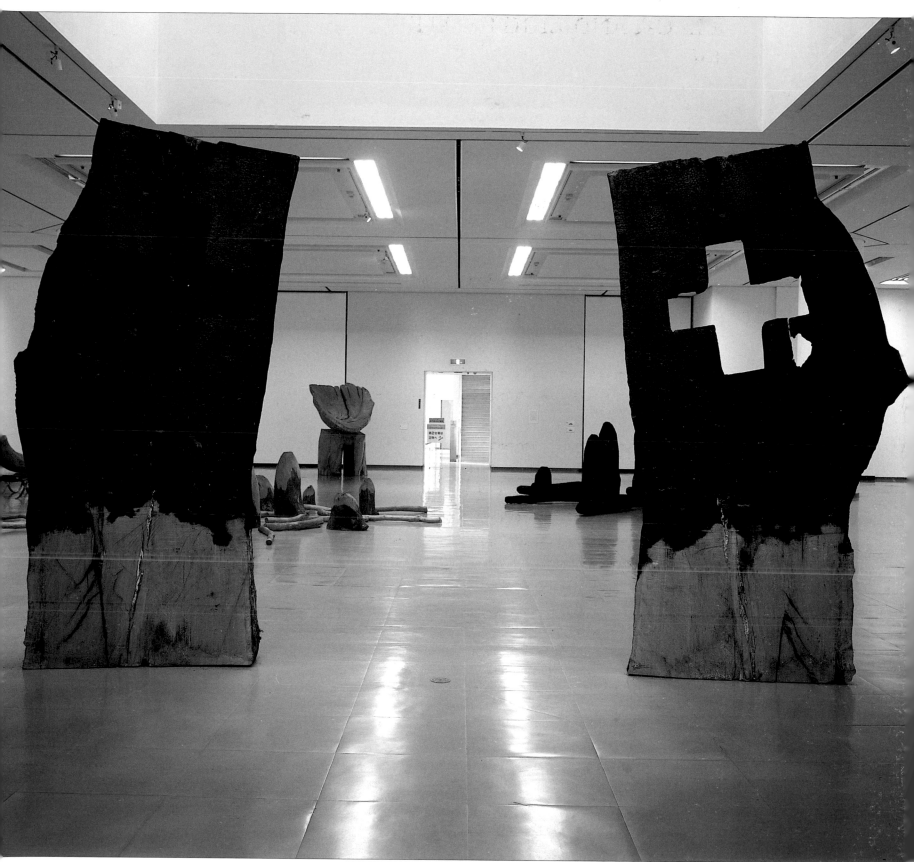

Black and White Gate, *installation*, 1994, Kamakura

Black and Light Gate, *detail, 1996, charcoal on paper, 50.5 × 30.5 cm*

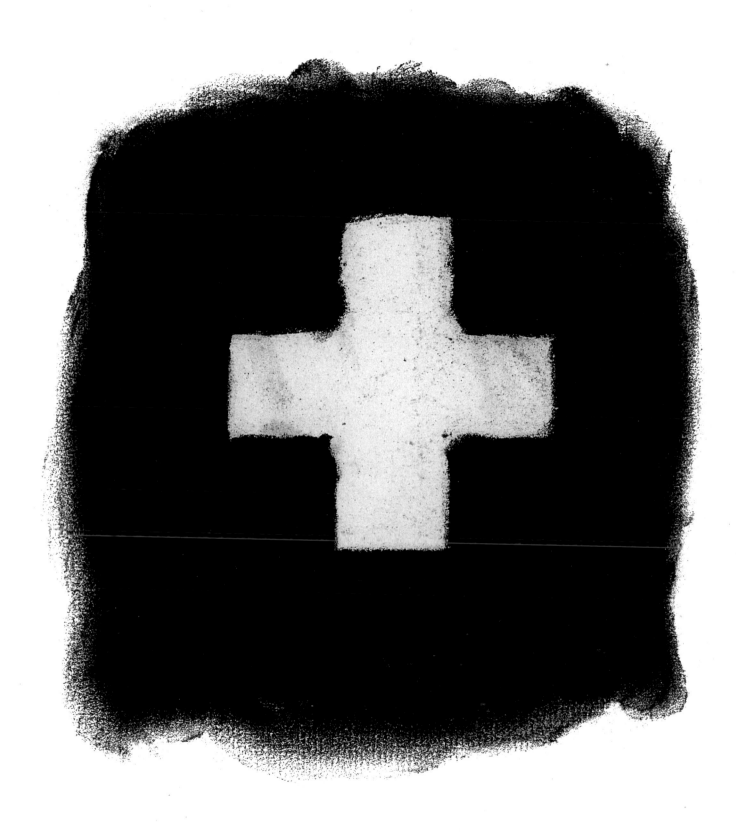

Black and Light Gate, *detail, 1996, charcoal on paper, 50.5 × 30.5 cm*

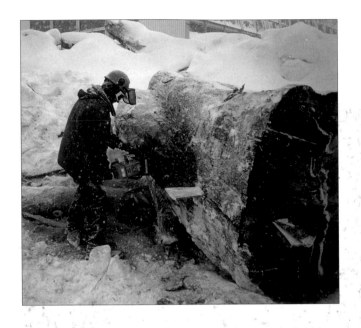

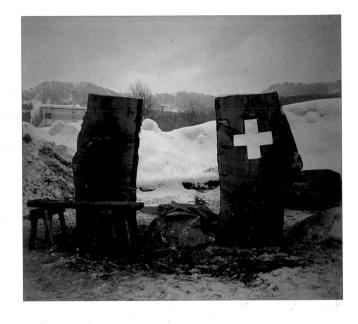

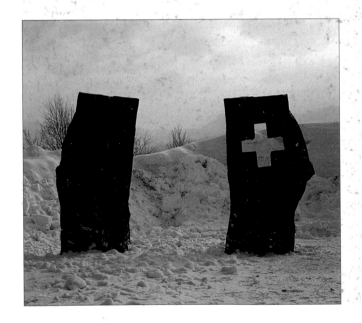

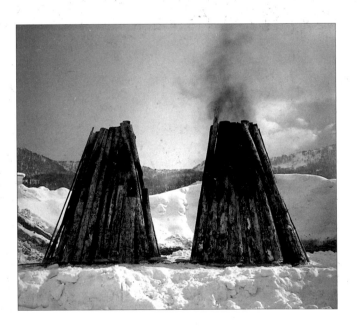

Preparing Black and Light Gate, 1994, Otoineppu

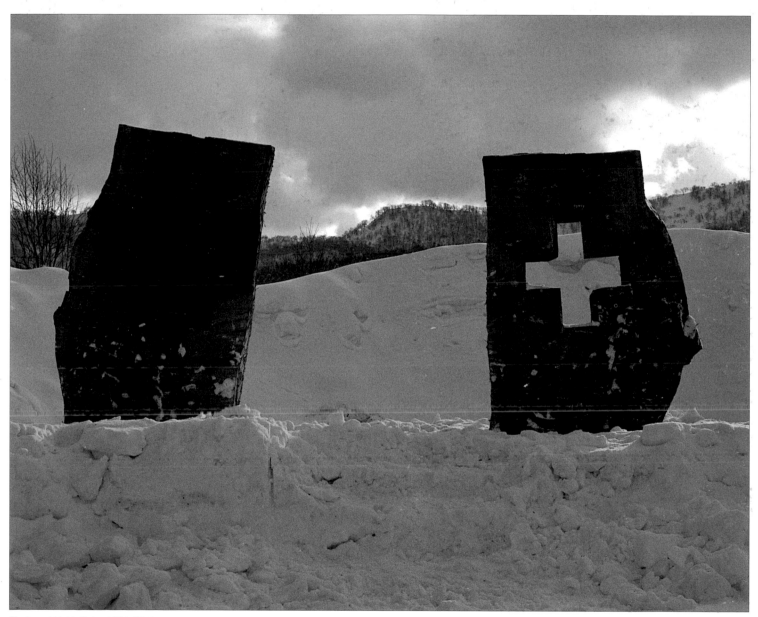

Black and Light Gate, 1994, *Otoineppu*

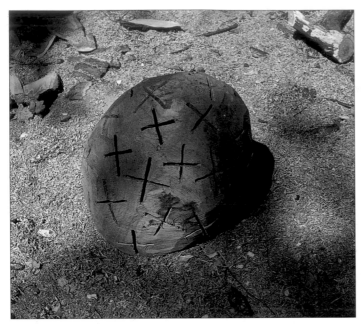

Criss Cross Egg, *1989, oak, Finland*

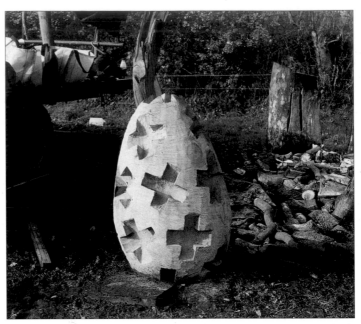

Charred Cross Egg II, *1994, oak, Sussex, England*

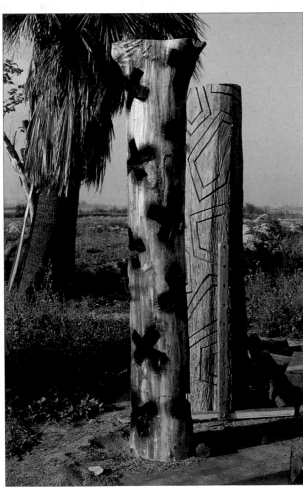

Charred Cross Column, *1995, plane, Barcelona*

Loosened Cross, *1995, madrone, California*

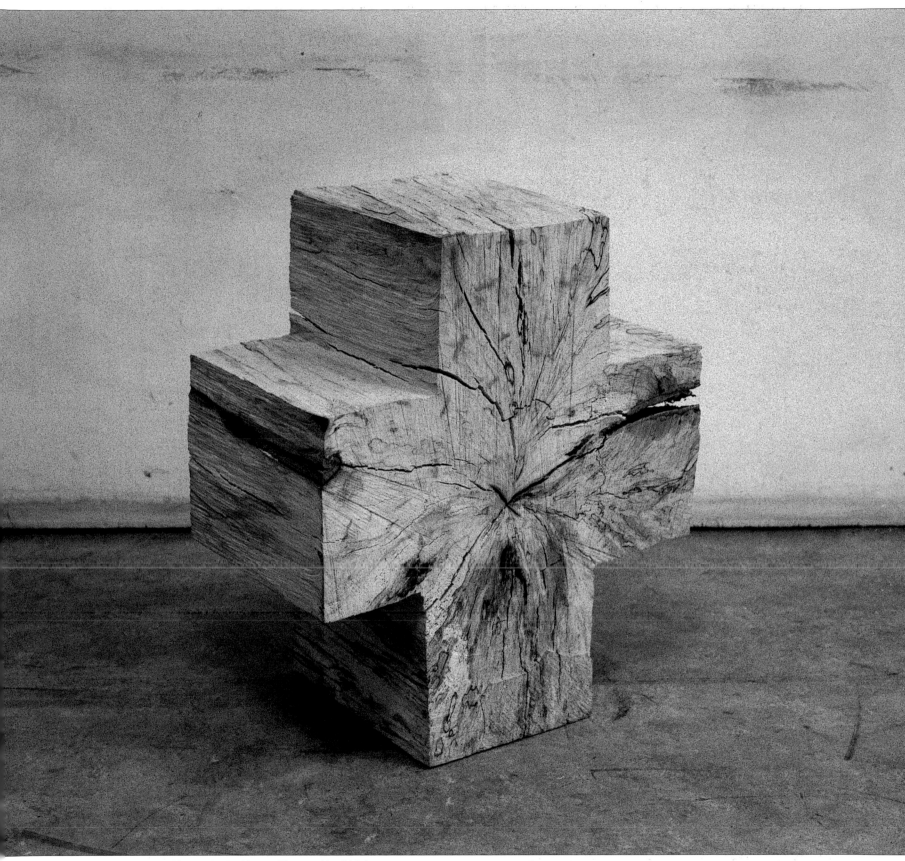

Hornbeam Cross, 1995, hornbeam, Blaenau Ffestiniog, North Wales

BIOGRAPHY

1945 David Nash born in Esher, Surrey, England.

1965-7 Studied at Kingston College of Art, Sculpture Department.

1966 Bought a semi-detached and one derelict detached cottage at Fuches Wen, Blaenau Ffestiniog.

1967 Moved permanently to Blaenau Ffestiniog.
Built first *Tower* at Fuches Wen, blown over in high winds.

1968 Worked for Economic Forestry Group digging ditches and planting trees.
Taught art at evening classes in Blaenau Ffestiniog.
Sold the Fuches Wen cottages and bought Capel Rhiw, with its adjacent schoolhouse.

1969 Postgraduate year at Chelsea School of Art.
Completed *Chelsea Towers*, I, II and III.

1970 Returned to North Wales.
Built *The Waterfall* on interior east wall in Capel Rhiw.
Made first carved works including *Nine Cracked Balls*.

1971 Began working on piece of woodland at Cae'n-y-Coed, Maentwrog.
Made first table sculpture, *Table with Cubes*.

1972 Built hut at Cae'n-y-Coed.
Married Claire Langdown.

1973 Visited Paris. Revisited Brancusi's studio.
First one-man exhibition: 'Briefly Cooked Apples', at the York Festival.
Son William born.

1974 Part-time teaching at Wolverhampton and visiting lecturer to several art colleges in Britain.

1975 'Condition of Sculpture' exhibition at the Hayward Gallery, London.
Received Major Bursary from the Welsh Arts Council.

1976 'Loosely Held Grain', Arnolfini Gallery, Bristol.
Took part in 'Summer Show III' at Serpentine Gallery.

1977 Son Jack born.
Planted *Ash Dome* at Cae'n-y-Coed, March.
'From Wales', Fruitmarket Gallery, Edinburgh.

1978 Sculptor in residence at Grizedale Forest, Cumbria, made: *Running Table*, *Horned Tripod*, *Wooden Waterway*, *Willow Ladder* and *Larch Enclosure* (a planting piece).
Arts Council of Great Britain film 'Woodman' made by Peter Francis Browne.
'Fletched Over Ash', Air Gallery, London.
Attended Sculpture Symposium at Prilep, Yugoslavia.
Carved the *Wooden Boulder* at Bronturnor, and rolled it into a stream.

1979 Sent *Prime Block* to 'Corners' exhibition at Elise Meyer Gallery, New York.
Given freehold ownership of Cae'n-y-Coed by his father.
Worked on Bronturnor oak, at Maentwrog.

1980 Selected as one of eight artists for 'British Arts Now' at the Guggenheim Museum, New York.
Planting commission at Southampton University.
Travelled with family in USA.
Took part in International Sculpture Conference in Washington, DC, made *Washington Stove*.
Exhibited in Rotterdam and in Venice.
Showed *Sea Stoves* at 'Art and the Sea' exhibition, Glasgow.

1981 Carried out field trips with Dutch students in the Biesbos, The Netherlands.
Yorkshire Sculpture Park Fellowship. Lived in Wakefield with family from September until January 1982.
'Pyramids and Catapult: 20 days with an Elm' shown in Leeds.
Work included in 'British Sculpture in the Twentieth Century Part II', Whitechapel Art Gallery.

1982 Travelled to Japan to carry out project 'Twenty days with a Mizunara' in Kotoku, Upper Nikko province.
Resulting works shown in touring exhibition 'Aspects of British Art Today', at Tokyo Metropolitan Art Museum, Tochigi, Osaka, Fukuoka and Sapporo.
'Wood Quarry' at Kröller-Müller Museum, Otterlo, The Netherlands.
Fellowship Exhibition, Yorkshire Sculpture Park.
Showed 9-metre drawing of full-size larch trunk at the Hayward Annual British Drawing show.
Other exhibitions in New York, Cardiff, Carlisle, the LYC Museum, Cumbria and Ireland.

1983 *Flying Frame* purchased by Tate Gallery, London.
First fletch on *Ash Dome*.
Sod Swap, Hyde Park and Cae'n-y-Coed shown at Serpentine Gallery, London.
Project at Forest Park, St Louis, Missouri, using red oak and maple, made the first *Charred Column*.
Elm project, New Inn, Tipperary, Ireland.
Joins with local parent group to research starting a Steiner Junior School.

1984 Represented in 'Survey of Recent International Painting and Sculpture', Museum of Modern Art, New York.
Planted *Blue Ring*.

Participated in ROSC International Exhibition, Dublin.
Made *Bramble Ring* at Cae'n-y-Coed, Maentwrog.
Travelled with family in Japan making works at several venues and exhibiting in Tochigi, Miagi and Fukuoka from September to December.

1985 Made *Ice Stove* at the confluence of the Mississippi and Missouri rivers.
Planting commissions *Divided Oaks* and *Turning Pines* at the Kröller-Müller Museum, Otterlo, The Netherlands.
Project and Exhibition with Sogetsu Kaiken Ikebana School, Tokyo.
Ysgol Steiner Eryri opens with forty-five children.
'Elm, Wattle, Gum', exhibition and publication at Heide Art Gallery, Melbourne, Australia.

1986 Makes *Black Dome* pieces at Allt Goch, Blaenau Ffestiniog and in the Forest of Dean.
'Tree to Vessel' first solo exhibition at Juda Rowan Gallery, London.

1987 One of six artists selected for 'A Quiet Revolution, British Sculpture since 1995' shown in Chicago, San Francisco, Newport Beach, Washington, DC, and Buffalo, USA.
Wood Primer published by Bedford Press.
First solo show at LA Louver, Los Angeles.
Black Light – White Shadow commission for Hiroshima Museum of Fine Arts, Japan.
Standing Frame white oak, commission for Walker Arts Centre, Minneapolis, Minnesota.

1988 Channel 4 Television film: 'Stoves and Hearths'.
Above the Waters of Leith planting commission from Scottish National Gallery of Modern Art, Edinburgh.
Project and exhibition 'Chêne et Frêne', Tournus Abbey, France.
Ardennes project, Belgium. Exhibition at Gallery S65, Aalst.
Participated in 'Britannica 30 ans de sculpture', France.
Exhibition at Nishimura Gallery, Tokyo.
Planted *Serpentine Sycamores* and *Oak Bowl* at Cae'n-y-Coed, Maentwrog.
Transplanted curved larches at Cae'n-y-Coed into six groups.

1989 Kurasaari Island project.
'Oak and Birch', Helsinki, Finland.
'Mosaic Egg', Annely Juda Fine Art, London.
Project and exhibition at Ile Vassivière, France, where he made *Charred Oak, Green Moss, Six Birch Spoons, Seven Charred Shapes*.

Worked with redwood in California, made *Strong Box, Red Throne* and *Charred Forms in Charred Stumps*.

1990 Exhibition at Louver Gallery, New York.
Touring retrospective exhibition at Serpentine Gallery, London, National Museum of Wales, Cardiff, and Scottish National Gallery of Modern Art, Edinburgh.
Exhibitions in Paris and Amsterdam.

1991 'Wood Quarry' project and exhibition, Mappin Art Gallery, Sheffield.
Converts derelict shop near Chapel into drawing studio.
'David Nash Sculpture', Mostyn Art Gallery, Llandudno, North Wales.
Comet Ball booklet and CD, produced in conjunction with Sound Events.
Exhibition at LA Louver Gallery, Venice, California.
'Walily' project at Radunin, Poland, together with Leon Tarasewicz.
'Poland Project' exhibition at Galerie S65, Aalst, Belgium.

1992 Exhibition 'David Nash: The Planted Works', at Louver Gallery, New York.
Exhibition at Peter Pears Gallery, Aldeburgh Festival.

1993 'The Planted Works', Manchester City Art Gallery.
Worked in village of Otoineppu, northern Hokkaido, Japan, in spring and summer.
'At the Edge of the Forest', BBC film made by Richard Trayler-Smith.
'Sheep Spaces', installation at Tickon, Langeland, Denmark.
'At the Edge of the Forest', Annely Juda Fine Art, London.

1994 Worked again in northern Hokkaido, Japan.
'Otoineppu Spirit of Three Seasons' touring exhibition, Hokkaido, Nagoya, Kobe, Saitama, Kamakura and Scuba (exhibition damaged in Kobe earthquake).
'Voyages and Vessels' touring exhibition, Joslyn Museum, Omaha, San Diego, Honolulu and Madison.
Nagoya commission *Descending Vessel*.
Exhibition at Nishimura Gallery, Tokyo.

1995 Projects in Hawaii and California.
Exhibition at Refusalon Gallery, San Francisco.
Project in Barcelona, Spain, 'Mes enlla del bosc'.
Exhibitions in Barcelona and Palma de Mallorca, Spain.

1996 Solo exhibitions at: Art Affairs, Amsterdam; Cairn Gallery, Nailsworth; Warwick Arts Centre; Henry Moore Institute, Leeds; Leeds City Art Gallery; Muhka, Antwerp; Annely Juda Fine Art, London; LA Louver, Los Angeles; S65, Aalst, Belgium.

17410 2 1425 SAT DR. KEN
 — 121.95
£21.95